IMAGES
of America

CHICAGO TO SPRINGFIELD
CRIME AND POLITICS IN THE 1920S

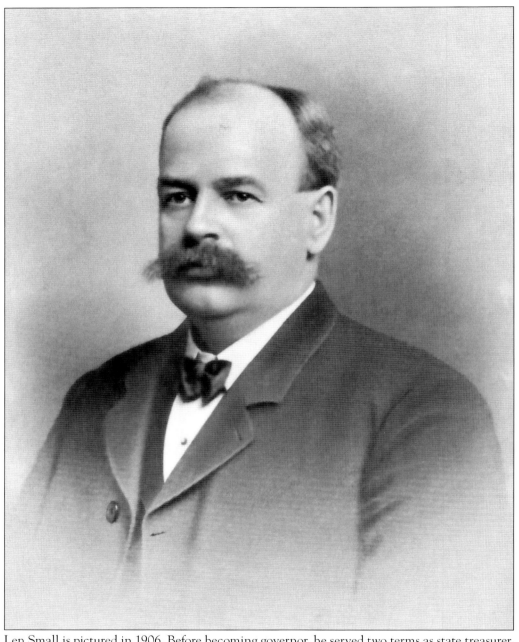

Len Small is pictured in 1906. Before becoming governor, he served two terms as state treasurer, and he kept interest money each time. (Herscher Area Historical Society and Museum.)

IMAGES
of America

CHICAGO TO SPRINGFIELD
CRIME AND POLITICS IN THE 1920s

Jim Ridings

ARCADIA
PUBLISHING

Published by Arcadia Publishing
Charleston, South Carolina

Printed in the United States of America

Library of Congress Control Number: 2010931332

For all general information, please contact Arcadia Publishing:
Telephone 843-853-2070
Fax 843-853-0044
E-mail sales@arcadiapublishing.com
For customer service and orders:
Toll-Free 1-888-313-2665

Visit us on the Internet at www.arcadiapublishing.com

To my wife, Janet, and my daughters, Stephanie and Laura

CONTENTS

ACKNOWLEDGMENTS

Thanks go to the Herscher Area Historical Society and Museum; Mary Michals of the Abraham Lincoln Presidential Library in Springfield; Betty Schatz and the Kankakee Public Library; the staff of the Kankakee Community College Library; Jeff Ruetsche of Arcadia Publishing; William Furry, executive director of the Illinois State Historical Society; Nancy Fike and the McHenry County Historical Society and Museum; the Dwight Museum; the Kankakee County Museum in Governor Small Memorial Park; and to Nancy (Sawyer) Wagner, Mary Haviland, and Paul Roeder. Thanks also goes to Bill Schaub and Jeff Thompson, managers of the Walgreens stores in Kankakee; Jack and Paula Goodwin of Paperback Reader in Kankakee; the Villages of Campus and Herscher; Campus State Bank; and State Bank of Herscher for their continued support of local history. Thanks to top journalists Rich Miller, Tom Roeser, Chuck Goudie, Steve Sanders, Eric Zorn, Bernie Schoenburg, and others for their reviews and encouragement. Research came from books listed in the bibliography on page 127 and from the microfilm and online files of the *Chicago Tribune*, *Kankakee Daily Republican*, *Kankakee Daily News*, *Time* magazine, and other sources.

The Kankakee County Museum and the Kankakee County Historical Society, other than providing research materials upon request, has not in any other manner participated in the preparation of this publication. It has not been consulted, nor had any part in formulating any interpretations or scholarly arguments that the author has felt justified in forming from any research materials acquired from the artifact, archival, and photographic collections of the Kankakee County Museum.

Unless otherwise noted, the images in this volume appear courtesy of the following:

ALPLM—Abraham Lincoln Presidential Library and Museum
CHM-DN—Chicago History Museum-*Chicago Daily News* collection
HAHSM—Herscher Area Historical Society and Museum
KCMPC—Kankakee County Museum Photographic Collection
KPL—Kankakee Public Library
KCC—Kankakee Community College
JR—Jim Ridings collection

INTRODUCTION

One might think this book is the story of bootleggers and gangsters in Chicago during the 1920s; it is not. It is the story of the crooked politicians who enabled and aided the bootleggers and the gangsters—allowing small-time gangs to grow into big-time organized crime.

Al Capone became the biggest of all Chicago gangsters. But would Capone have grown as big without Mayor William Hale Thompson, Gov. Len Small, and thousands of other politicians and political workers from city hall to the state house who were anxious to take the mobsters' money? Chicago police chief Charles Fitzmorris estimated that 65 percent of Chicago's police were on gang payrolls in the 1920s, not just protecting bootleggers, but pushing the stuff. It also was estimated that the Capone organization took in $100 million a year at its peak in the late 1920s, and $30 million of that went to police, politicians, and anyone else who needed their palms greased. Without the help of crooked politicians and police, Capone might have been just another gang boss, like Bugs Moran, Dean O'Banion, Spike O'Donnell, or Roger Touhy. Without these politicians and police, organized crime might never have become so organized.

There are many famous quotes regarding Illinois politics. Political boss Fred Lundin said it best and most accurately in the 1920s, "To hell with the public and our campaign promises, we're at the feedbox now!" Chicago alderman Paddy Bauler famously said in the early 1900s, "Chicago ain't ready for reform." One hundred years later, it seems it still isn't.

This book is about crime and politics in the 1920s and takes a special look at the four major political powers of the era: Chicago mayor William Hale "Big Bill" Thompson, Gov. Len Small, and bosses William Lorimer and Fred Lundin. The following pages give the background of organized crime not just in the hideouts of the hoodlums, but also in the offices of the elected representatives in city hall and in the capitol, from Chicago to Springfield, in between and beyond.

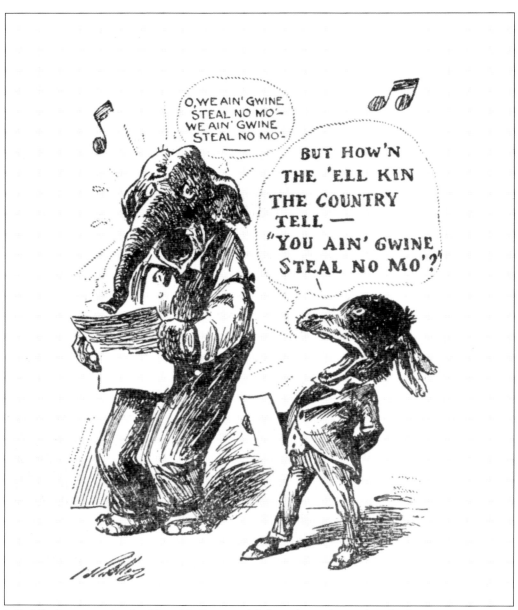

J. P. Alley's cartoon in the *Memphis Commercial Appeal*, nearly one hundred years ago, is just as timely today as it was then—no matter what party is doing the singing. (JR.)

One

Organized Crime Organizes

Gambling and Girls

While it was Prohibition in the 1920s that really allowed small-time gangs to become major crime families, gangs in Chicago already were very well organized and professional before that era. Criminals started organizing almost from the time Chicago was founded. Gambling and prostitution flourished from the start, and they were the first industries to rebuild after the great fire of 1871. Michael McDonald became the king of the gambling rackets in the 1880s, and the Levee District in the First Ward became a cesspool of prostitution, gambling, and other vices by the 1890s. Mont Tennes followed McDonald as the head of the gambling rackets, while "Big Jim" Colosimo took organized crime to a higher level.

Chicago's First Ward aldermen "Bathhouse John" Coughlin and "Hinky Dink" Kenna solidified the partnership between crime bosses and politicians in the 1890s. Their criminal-political machine was based on graft and protection money from the saloons, brothels, and gambling halls of the Levee. To hold onto their power, Kenna introduced "chain voting," where premarked ballots were taken to polls by election workers who continued until enough ballots were cast to make their candidate a winner.

Coughlin and Kenna were succeeded by a long list of Mob-connected politicians, continuing to the present era. A recent graduate was First Ward alderman Fred Roti. His father, Bruno "the Bomber" Roti, worked for Al Capone. The FBI called Fred Roti a made member of the Mob who ran the rackets, bribed judges, and eventually went to prison. Roti died in 1999 and is buried in Mount Carmel Cemetery, not far from Al Capone's grave.

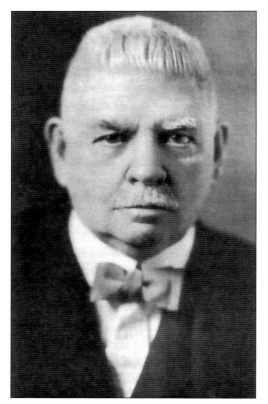

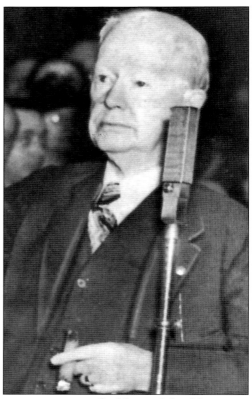

Bathhouse John (above, left) and Hinky Dink Kenna (above, right) helped Big Jim Colosimo get his start. Colosimo owned a famous nightclub where celebrities, politicians, and others from Chicago's elite gathered. Colosimo and his wife, Victoria (whom he dumped for showgirl Dana Wynter, at left), also owned as many as 200 brothels, many of them in the Levee District. He collected from the brothels to pay off the politicians and police. Colosimo's pimps and prostitutes worked the polls on election days. The brutal Colosimo also practiced white slavery, luring innocent women into forced prostitution. (All KCC.)

Johnny Torrio came to Chicago from New York when Colosimo called him. Torrio became the brains of the criminal organization. Big Jim was content with his prostitution and gambling and did not want to expand into the new bootlegging racket provided by Prohibition in 1920. Torrio had Colosimo killed; Al Capone was likely the gunman. (KCC.)

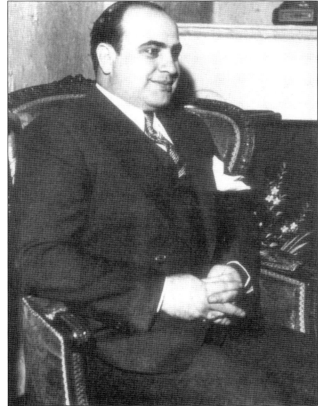

Torrio brought in his own protégé from New York—Al Capone. With Torrio's brain and Capone's muscle, they became the dominant gangsters in Roaring Twenties Chicago. Capone got his nickname "Scarface" after being slashed in a barroom brawl in New York but preferred friends call him "Snorky," meaning sharp or elegant. (KCC.)

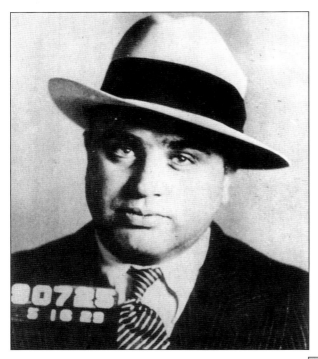

After Torrio was seriously wounded in 1925 by gangsters Bugs Moran and three others, he semi-retired and turned over the command of the organization to Al Capone. Capone found a friend and ally in Mayor "Big Bill" Thompson. (KCC.)

When scandals forced Mayor Thompson to withdraw from the race in 1923, William Dever (pictured) was elected mayor. Dever's crackdown on gangs had a minor impact on crime in Chicago, but it did cause Capone to look for another sanctuary. Capone went to suburban Cicero and Forest View and took over those towns. Any opposition in there was met with beatings and intimidation. Capone needed his own village officials in place, and he put his efforts into the 1924 municipal elections. (KCC.)

Edward Vogel (pictured), along with "Big Ed" Kovalinka and gangster Louis LaCava, picked the men who would run for office in Cicero and Forest View. Kovalinka was precinct committeeman and a protégé of Gov. Len Small. They appointed William "Porky" Dillon, a thug pardoned by Governor Small, as Forest View's police chief. Dillon also was a bagman in the selling of pardons by Governor Small. Together they helped deliver Cicero to Capone and his hoodlums. Vogel went on to be an important figure in the Mob's gambling rackets. (KPL.)

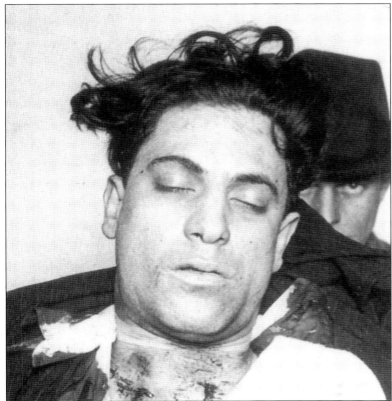

Election day 1924 saw gangsters patrolling the streets with guns and beating election workers and police. Capone's candidates won the election, but five people were killed that day, including Frank Capone, in a shoot-out with police. (KPL.)

13

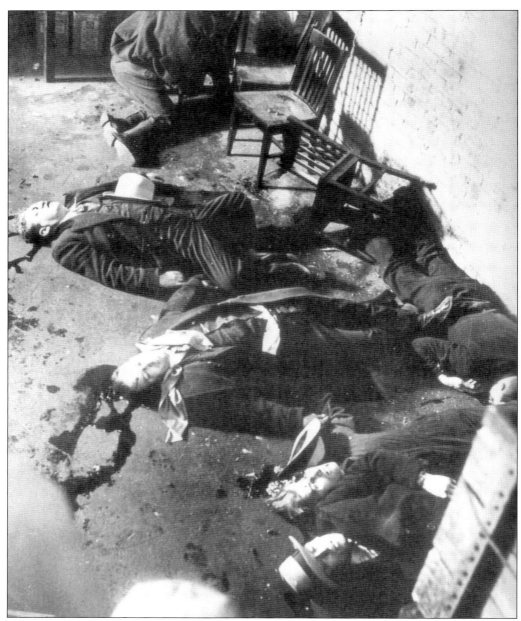

Chicago's most infamous gang murder was the St. Valentine's Day massacre in 1929, when Al Capone sent his gunmen to kill rival George "Bugs" Moran's men in their garage hideout on North Clark Street. Seven people were slaughtered. Capone's assassins, posing as Chicago police, lined Moran's men against the wall and opened fire. Moran was on his way there when he saw the "police" arrive, so he stayed back and avoided the carnage. (KCC.)

No one was arrested for the St. Valentine's Day murders. Rumor linked gangsters "Machine Gun" Jack McGurn, Frank Nitti, and Gus Winkeler to the planning of the crime. The only man positively connected to it was Fred "Killer" Burke (pictured). When he was arrested for the murder of a Michigan policeman, a machine gun found in his home was proven to be one used on St. Valentine's Day. When he was arrested, Burke was living with Viola Ostrowski Brennenman, a Kankakee woman. (KCC.)

Bugs Moran was the intended target on St. Valentine's Day. He might still have been in a prison cell, and no threat to Capone, except he was paroled in 1923 after bribing the men who ran the "pardon mill" in Governor Small's administration. (KCC.)

15

While some politicians have always worked cooperatively with mobsters, their partnership sometimes resulted in murder. In 1926, William McSwiggin, an assistant state's attorney, was gunned down outside a Cicero speakeasy. State senator Albert Prignano (above left), who was allied with Capone in the gambling rackets, had a dispute over payoffs with Frank Nitti, who believed Prignano was trying to organize his own racket. Nitti had assassins shoot and kill Prignano in 1935 at his front door in front of his wife, mother, and eight-year-old son. A few months later, state representative John Bolton (above right) was gunned to death. Suspects in that murder were mobsters Louis "Little New York" Campagna, Angelo Lazzia, Frank Nitti, state representative James Adduci (left), and state senator Daniel Serritella. (All KPL.)

Daniel Serritella was Capone's man in city hall. Mayor Thompson appointed him city sealer and in charge of regulating merchants. Serritella was convicted in 1932 for taking payoffs from merchants to allow shortchanging of customers. (KPL.)

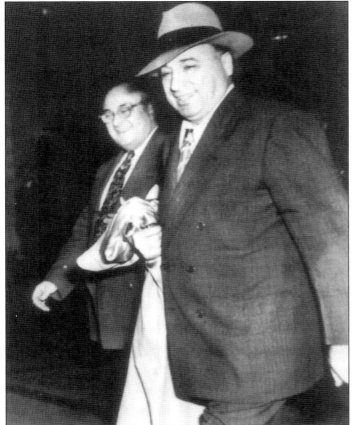

Daniel Serritella (left), seen here with Ralph Capone, was elected state senator in 1931 and served until 1943. Jake Guzik was arrested in 1944 for election fraud in Serritella's last campaign. (KCC.)

17

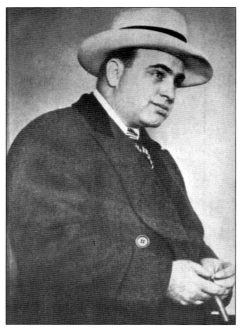

Al Capone lent money and muscle to his candidates. The campaign for the April 1928 primary election in Chicago was known as the "Pineapple Primary" because gangsters tossed about 60 hand grenades in the campaign. On March 21, Republican committeeman and gangster Giuseppe "Diamond Joe" Esposito was shot dead in front of his wife and daughter. Esposito worked for Sen. Charles Deneen, and a few days later Deneen's Chicago home was bombed. On Election Day, Octavius Granady, an African American candidate challenging the Mob's choice for committeeman in the "Bloody 20th" Ward, was gunned down. Twenty-three people were indicted, four policemen and three gangsters went on trial, and yet no one was convicted. (KCC.)

People in Paul Boldt's store in Chicago drink bootleg beer in front of a portrait of Gov. Len Small just before the 1924 election. (ALPLM.)

Chicago mayor Anton Cermak (seen here) was assassinated while appearing alongside President-elect Franklin Roosevelt in Miami in 1933. The accepted theory is that it was an attempt on Roosevelt's life by a lone anarchist, yet some historians disagree. Cermak was connected to gangsters who were rivals of Capone. Less than two months before Cermak was killed, Chicago police raided Frank Nitti's office, shooting and seriously wounding Nitti. (ALPLM.)

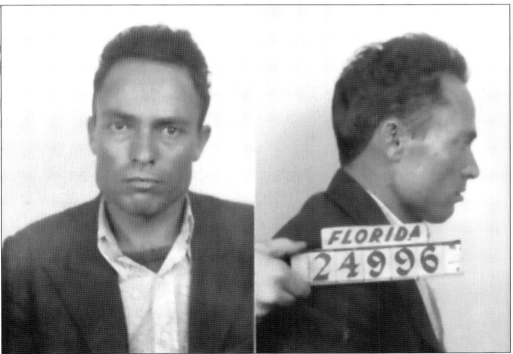

Giuseppe Zangara, a Sicilian immigrant, claimed he acted alone because he was an anarchist and Roosevelt was his target. But Zangara didn't have much time to change his story. He was executed in Florida's electric chair on March 20, just 32 days after the shooting. People such as columnist Walter Winchell, Judge John Lyle, and Chicago Crime Commission chief Frank Loesch all believed it was a Mob hit ordered by Nitti as revenge. (KPL.)

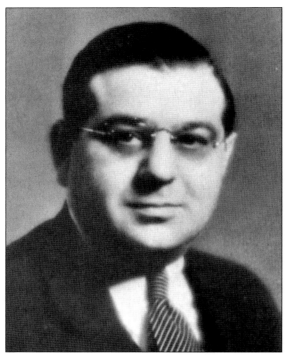

State representative Peter Granata (seen here) was part of the political-gangster alliance. His brother Bill campaigned against gangster state representative James Adduci and was murdered. William McSwiggen, Paul Labriolia, Octavius Granady, Frank Christensen, Charles Gross, Clem Graver, Bill Drury, Anthony D'Andrea, and Benjamin Lewis (and likely Anton Cermak) are just a few of the better-known politically connected murders by the Mob in Chicago over the years. (KPL.)

Chicago Cubs catcher Gabby Hartnett got in trouble with the major-league baseball commissioner for this picture with Al Capone and son in 1931. Next to Capone's son is state representative Roland Libonati. This and the St. Valentine's picture were taken by legendary newspaper photographer Tony Berardi, who died in a Kankakee retirement home in 2005. (KPL.)

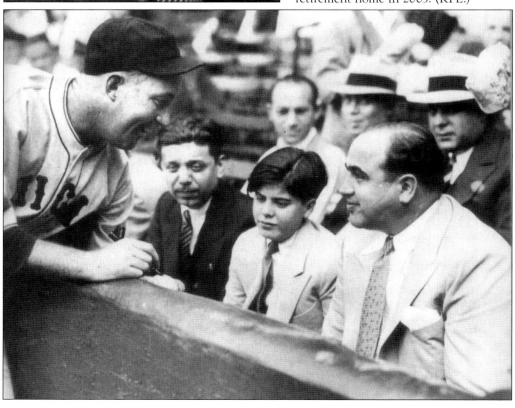

Two

BIG BILL THOMPSON
BUILDING AND BLUSTER

William Hale "Big Bill" Thompson is considered to have been the most corrupt mayor in Chicago's history. Thompson's administration was marked with theft, corruption, and wide-open gangland violence. He was mayor from 1915 until 1923, when scandal forced him from office. He was elected again in 1927 with a lot of money and muscle from Al Capone.

Gangsters ruled Chicago during Thompson's era. His 1927 campaign pledge was to reopen the closed speakeasies, and in a campaign speech he claimed he would "open 10,000 more." Thompson took money from Al Capone, Bugs Moran, Spike O'Donnell, and any other gangster who wanted protection. All the way up the line, from the merchant who paid a cop, who paid his sergeant, who paid a politician, and so on, a piece went into the pockets of Thompson and his political machine.

He liked the name "Big Bill the Builder." Much was built during his administration, a time of prosperity and boom. He was free with the taxpayers' money when it came to public works, and his name can be found today on plaques on bridges, train stations, and other sites all across the city.

But he also was an embarrassment. His complicity with gangsters earned Chicago a reputation for gangland violence, and some consider this Chicago's chief legacy all across the world. Business was done through overpriced contracts for city services, awarded to politically connected people who paid kickbacks, and the services were performed poorly or not at all.

The scandals in which Thompson was involved would fill a resume for a dozen other crooked politicians. When he was defeated in 1931, the *Chicago Tribune* editorialized:

> For Chicago, Thompson has meant filth, corruption, obscenity, idiocy, and bankruptcy. He has given the city an international reputation for moronic buffoonery, barbaric crime, triumphant hoodlumism, unchecked graft, and a dejected citizenship. He nearly ruined the property and completely destroyed the pride of the city. He made Chicago a byword for the collapse of American civilization. In his attempt to continue this, he excelled himself as a liar and defamer of character.

When he died, he left two safety deposit boxes containing $1.5 million.

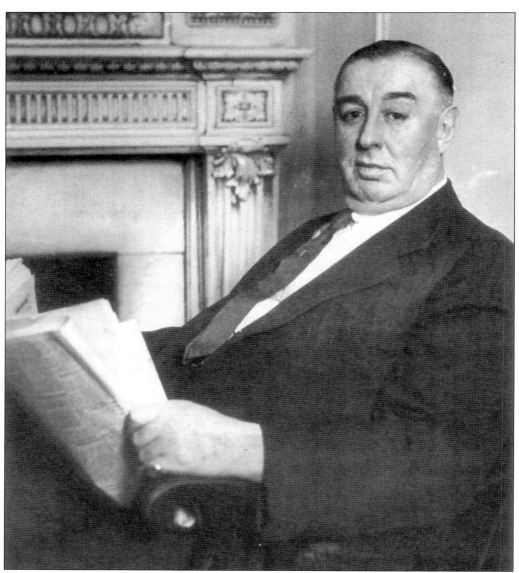

Big Bill Thompson was a colorful character who amused and outraged people at the same time. During World War I, Thompson was pro-German and anti-British. He once promised to hold a book burning on the shores of Lake Michigan for books of British history. He promised to punch the king of England "in the snoot" if he ever came to Chicago. While out of office in 1924, Thompson set sail on a "scientific" expedition to search for tree-climbing fish in the South Seas; his boat did not even get to the Mississippi River. Thompson held a debate between himself and two live rats, which he used to portray his opponents, in the 1927 election. Thompson is credited with coining the Chicago term, "Vote early and often." (HAHSM.)

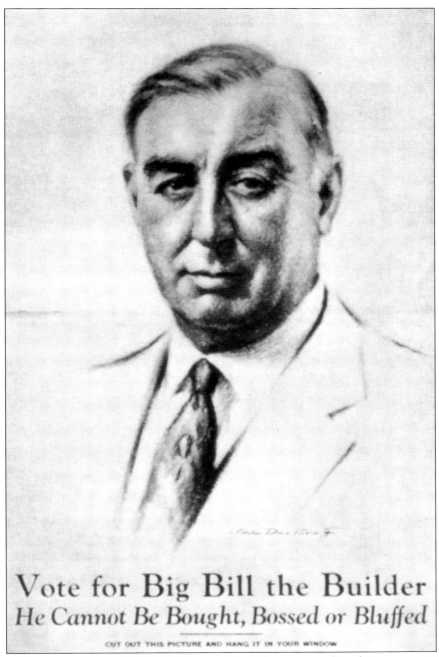

Vote for Big Bill the Builder
He Cannot Be Bought, Bossed or Bluffed

CUT OUT THIS PICTURE AND HANG IT IN YOUR WINDOW

But not all was amusement. In his 1931 campaign, Thompson referred to opponent Anton Cermak as "a Bo-Hunk with a pushcart." Campaigning for Len Small in 1931, Thompson told farmers that hog prices would drop if Henry Horner was elected, since Horner was Jewish. *Time* magazine quoted Thompson, "Furthermore, Jews run pawnshops, and the first thing Horner will do if he gets to Springfield is open a pawnshop." *Time* added, "In the primary, Mayor Thompson employed 'stooges' in rabbinical dress to ridicule Judge Horner's racial origin." In 1937, Thompson spoke to a Chicago pro-Nazi group on "Reds and Jewish bankers." (KCC.)

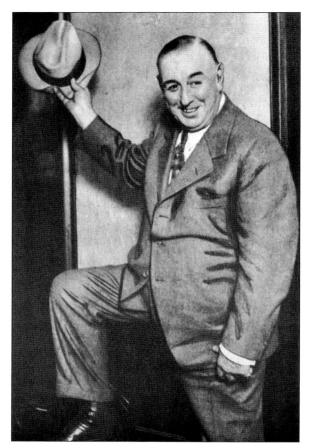

Thompson appointed several crooked police chiefs. Chief John Garrity was allegedly involved with pimps and bootleggers, while Chief Charles Fitzmorris admitted half his police force was involved in bootlegging. Chief Mike Hughes attended memorial services for slain mobster Dean O'Banion. Chief William Russell said, "Mayor Thompson was elected on an open-town platform. I assume the people knew what they wanted when they voted for him. I haven't any orders from downtown to interfere with the policy racket." (ALPLM.)

Gangster Jack Zuta contributed $50,000 to Mayor Thompson's campaign in 1927. He said, "I'm for Big Bill, hook, line and sinker, and Big Bill is for me, hook, line and sinker." Zuta reputedly ordered the murder of Mob-connected *Chicago Tribune* reporter Jake Lingle. A few months later, to take the heat off, Al Capone had Zuta murdered. (KCC.)

Fur Sammons was one of the Roaring Twenties' most cold-blooded murderers. He went to prison, and when the state supreme court denied his appeal, shady Chicago lawyer W. W. O'Brien shopped for a friendlier judge. He found McHenry County judge Edward Shurtleff (right), who released Sammons in 1932—basically overturning the Illinois Supreme Court. Sammons went back to work, as a machine gunner for Frank Nitti, before being sent back to prison. Shurtleff was speaker of the house in 1909 when William Lorimer's fraudulent election was engineered. When state auditor Oscar Nelson was brought to trial for financial malfeasance, Judge Shurtleff dismissed the case. Below is a postcard from a grateful Sammons to Judge Shurtleff. (Both McHenry County Historical Society.)

Dear Judge Your Honor July 26
I take this opportunity of thanking you for my release and would have wrote you sooner only I have been too busy.
Yours truly
Fur Sammons

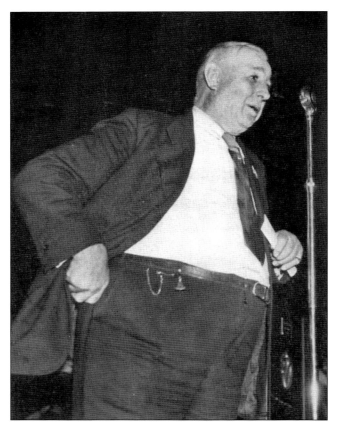

On the office wall of the mayor of Chicago, Thompson had portraits of Abraham Lincoln and Al Capone. And in his headquarters, Capone had portraits of George Washington, Abraham Lincoln, and Big Bill Thompson on his wall. Capone biographer John Kobler called Mayor Thompson "the hero of every pimp, whore, gambler, racketeer, and bootlegger in Chicago." (JR.)

William Lorimer was the political boss of Chicago who helped Big Bill Thompson and Len Small become political powers. Lorimer built the first highly effective political machine in Chicago, becoming a sort of "kingmaker" who made mayors, senators, and governors. At the same time, Lorimer's businesses benefited from his political connections by grabbing city contracts. (JR.)

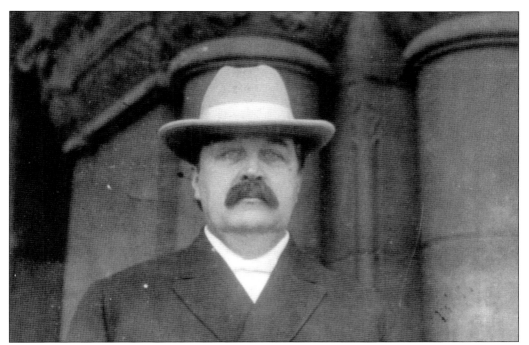

William Lorimer was elected to Congress in 1894 and then to the U.S. Senate in 1909. In those days, senators were chosen by the state legislature, not by the popular vote. It was proven that Lorimer spent about $100,000 to bribe several state legislators to vote for him. The U.S. Senate held hearings and decided that Lorimer won his seat by "corrupt practices" and threw him out of office in 1912. Lorimer made his comeback into public life when Big Bill Thompson took office as Chicago's mayor in 1915, and he helped build the Chicago Republican machine bigger than ever. (ALPLM.)

The other political powerhouse in Chicago was Fred Lundin, who started out as a huckster with a patent medicine wagon. He would extol the benefits of his Juniper Ade drink while two African American men with banjos provided music to draw crowds. (JR.)

Lundin got into Chicago politics in the 1890s. His real talent was as a kingmaker and political boss. It was Lundin who picked playboy real estate developer William Hale Thompson and made him mayor. Lundin sold Big Bill the same way he sold his snake oil medicine. "He may not be too much on brains, but he gets through to the people," Lundin said of Thompson. (ALPLM.)

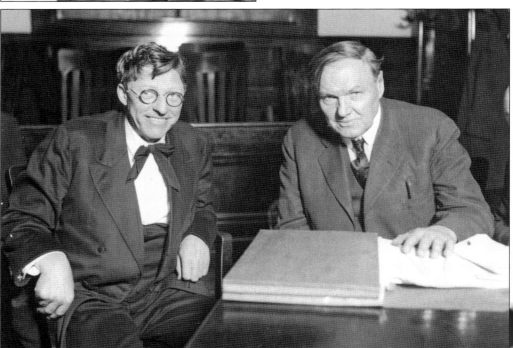

Several scandals rocked the Thompson administration. Thompson and his cohorts cheated Chicago out of $2.2 million in fake expert fees in a city real estate project. They were convicted and ordered to pay $1.7 million, a decision their lawyers managed to get reversed on appeal. Another scandal involved the theft of $1 million in fake contracts for material for Chicago schools. Lundin and 15 others went on trial in 1923 and beat the rap thanks to lawyer Clarence Darrow (right). (CHM-DN-0075818.)

Judge John Lyle ran against Thompson for mayor in the 1931 primary. At rallies, Lyle displayed machine guns and other weapons confiscated from gangsters. Lyle said, "The real issue is whether Al Capone is to be authorized to rule Chicago again through the medium of a dummy in the mayor's chair. These (weapons) are the fruits of William Hale Thompson's administration. I lay at the door of the Thompson administration every murder by gangsters in the last 12 years." (KCC.)

Lyle lost the primary, but Democrat Anton Cermak beat Thompson in the election, and Cermak was no reformer. He was a Democrat party boss and was allied with gangsters who were rivals to the Thompson-Capone faction. Cermak is credited as the architect of the Chicago Democratic machine, while Thompson is credited as the reason there has been no Republican mayor in Chicago since. (HAHSM.)

In Chicago, Al Capone had the police, the mayor, and the governor in his hip pocket, and they let Capone have the city to do as he pleased. This gave Capone power few have ever held in the United States. It is also why federal agent Eliot Ness (pictured) and the "Untouchables" had to be formed in 1928. Ness and his squad earned the moniker because they were the only officials or lawmen in Chicago who could not be bribed. (HAHSM.)

Mayor Thompson believed that reformers were the real enemy. Robert Randolph originated the Untouchables task force to counter "the most corrupt and degenerate municipal administration that ever cursed a city, a politico-criminal alliance formed between a civil administration and a gun-covered underworld for the exploitation of the citizenry." Chicago police once battled federal agents after a Thompson campaign worker was shot in a saloon by an agent. To Mayor Thompson, Al Capone was a friend, while Eliot Ness was not. (CHM-DN-0081244.)

Three

GOVERNOR LEN SMALL
GANGSTERS AND GRAFT

It could be debated that Len Small was one of the most corrupt governors this country has seen. He was governor of Illinois from 1921 to 1929, and it was during his administration that the Chicago Mob was allowed to grow and become firmly established. But Governor Small's corruption went far beyond helping to enable the Mob.

Before he became governor, Small was state treasurer. He embezzled more than $1 million of state funds in a money-laundering scheme by depositing state funds in a bank that did not exist. Six months after taking office as governor, he was indicted for this crime. For three weeks Small ran from the sheriff to avoid arrest, threatening to call out the National Guard "with bayonets" against him. Meanwhile, his lawyers claimed that as governor he was above the law, citing the divine right of kings. Their argument in court was that "the king could do no wrong."

Len Small went to trial and was acquitted by a jury that was allegedly bribed by Al Capone's hoodlums. And even though the jury acquitted him, a civil suit ended with the Illinois Supreme Court forcing Small to repay the state $650,000 of the money he stole. In the book *Political Corruption in America*, Mark Grossman wrote, "Although it is obvious that Small was one of the most corrupt, if not the most corrupt, governor in American history, his name is almost wholly forgotten."

Gov. Len Small purportedly sold thousands of pardons and paroles, including many to gangsters, murderers, white slavers, and even to cop killers. He was a partner with Mayor Thompson in an incredibly corrupt political machine. Small wrecked civil service and brought back the spoils system, and he docked state workers' pay for his own supposed slush fund. Facing impeachment, Small persuaded the legislature to pass a law exempting the present governor from removal. He also had ties to the Ku Klux Klan, and they endorsed his campaigns.

Today, in his hometown of Kankakee, Small's family owns the newspaper and endows the local museum in Governor Small Memorial Park.

Lennington Small was born on June 16, 1862, on the family farm near Kankakee. He was one of six children of Abram and Calista Small. At left are Abram (left), his son Len (center), and grandson Leslie. Below are two early portraits of Len Small. (All KCMPC.)

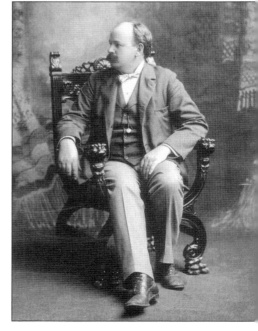

Abram Small grew superior strains of rhubarb and developed a method of growing the perennial plants indoors, seen above, in the winter. Below are his fields with the state hospital in the background. Agriculture was an avocation his son shared. (Both JR.)

Len Small married Ida Moore in 1883, and they had three children, (from left to right) Leslie Small, Ida May Inglesh, and Budd Small, pictured above in the 1890s. Below are Len Small and his family on the porch of their house in Kankakee in 1900. (Both JR.)

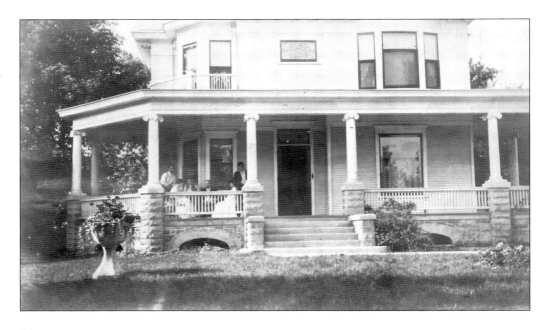

Len Small's first major political job came in 1897, when Governor John Tanner appointed him to the board of the Eastern Illinois Hospital for the Insane in Kankakee, which was a reward for political work. The hospital was an opportunity for theft and graft by those in charge, and Len Small got rich from the coal contracts and more. No one received a job or kept it without kicking back some of their pay, and no merchant did business with the hospital without an added graft payment. Small used hospital horses on his farm and had hospital employees work on his property and on his campaigns. (JR.)

Major scandals at the state hospital in 1902 and 1903 included docking employee paychecks for a political slush fund. Supt. Joseph Corbus admitted it, and so did Small, who also admitted keeping the interest on hospital funds. Pictured here are games at the state hospital in 1900. (HAHSM.)

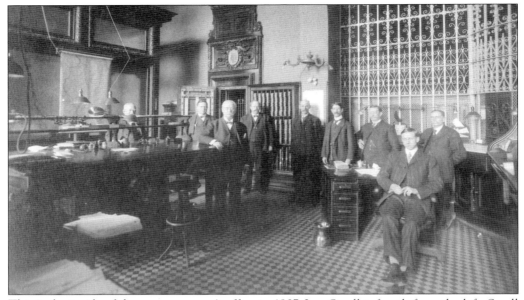

This is the inside of the state treasurer's office in 1907; Len Small is fourth from the left. Small kept $200,000 in interest in state funds and did not deny it. A law was passed to prevent it from happening again. During his second term as treasurer a decade later, his theft was on a grander scale. (KCMPC.)

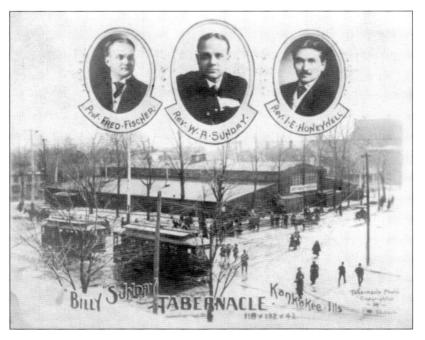

Evangelist Billy Sunday built this huge pavilion in Kankakee for a three-week revival in 1907. Len Small made a controversial altar call, which cynics did not believe. (JR.)

LEN. SMALL of Kankakee

Senator Small never was defeated by the people at the polls. He has served his county as Supervisor, Circuit Court Clerk, Chairman of Republican Central Committee. He has represented his district as State Senator and is on record as one of the most efficient and constructive members of the Illinois Legislature.

In 1904 he was elected State Treasurer of Illinois by the greatest majority ever given a candidate for that office.

In 1910 he was appointed by President William H. Taft to the responsible position of Assistant Treasurer of the United States.

PRIMARY ELECTION APRIL 9, 1912

Extract from Len. Small's Address at Springfield, February 12, 1912.

"It has been the ambition of my life some time to become Governor of the great State of Illinois. I value my reputation and my friends and their confidence more than I value office. If being elected Governor should make me a demagogue and a hypocrite, forgetful of my friends and unmindful of my obligations to the people, then may God be merciful and prevent my election."

This is a handbill from Len Small's first run for governor in 1912. (JR.)

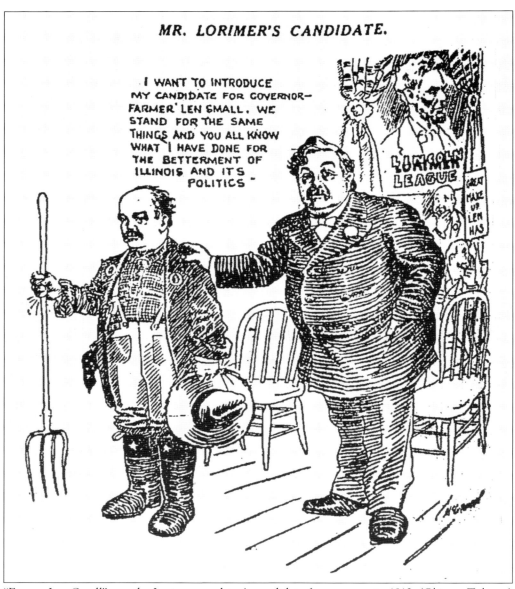

"Farmer Len Small" was the Lorimer machine's candidate for governor in 1912. (*Chicago Tribune.*)

KANKAKEE DAILY REPUBLICAN

VOLUME XXIV · KANKAKEE, ILLINOIS, SATURDAY, MARCH 30, 1912 · NUMBER 204

'SMALL WILL MAKE THE BEST GOVERNOR ILLINOIS EVER HAD'

—CHAIRMAN JEWELL AT DANVILLE

TRUST PRESS PASSES OUT THE ORDER TO WAGE WAR-FARE AGAINST LEN. SMALL, THE FARMER CANDIDAT

VERMILION AND EDGAR COUNTIES SWING INTO THE LEN. SMALL COLUMN: CRUSHING DEFEAT FOR DENEEN

DIKE BREAKS; WATER FLOODS COUNTRY; MANY LIVES ARE LOST; GREAT DAMAGE DONE

THOUSANDS GREET FARMER CANDIDATE IN EASTERN ILLINOIS

DENEEN CAMPAIGN IS IN A STATE OF COLLAPSE

RAILROAD MEN ALL OVER ILLINOIS ARE IN LINE FOR LEN. SMALL

KANKAKEE D

VOLUME XXVI · KANKAKEE, ILLIN

SMALL'S CANDIDACY IS GAINING STRENGTH EVERY DAY ALL OVER THE STATE

From Galena to Cairo and from Danville to Quincy He Is Regarded as the "Man of the Hour."

KANKAKEEAN IS THE MOST TALKED ABOUT MAN FOR GOVERNORSHIP

In Chicago, as Well as in Almost Every City, Hamlet and Village in the State, Len. Small Is Deemed the Logical Candidate.

During Len Small's first run for governor in 1912, his *Kankakee Daily Republican* ran front-page headline stories every day for months on how Small was adored by the voters and how he was going win in a landslide. When the votes were counted, he lost in a landslide. (Both KCC.)

KANKAKEE DAILY REPUBLICA

VOLUME XXIV · KANKAKEE, ILLINOIS, THURSDAY, APRIL 4, 1912

LEN. SMALL'S NOMINATION BY REPUBLICANS OF THE STATE MEANS END OF TRUST PRESS RULE IN GOVERNOR'S CHAIR

The Tribune Gives Orders to Its Henchmen to Drop Wayman, Hurburgh, Yates and Jones and Endeavor to Save Deneen.

Victor Lawson, the Multi-Millionaire, Owner of Chicago Record-Herald, the Evening News, Etc., Shouts, Down With Len. Small.

LAWSON PAYS $17.32 TAXES ON HIS MILLION AND A HALF RESIDENCE

Chicago Taxdodgers Yell Honesty, But

This edition repeats the theme used in Small's newspaper for decades that the *Chicago Tribune* was trying to control the state and was out to ruin Small. (KCC.)

Lt. Gov. John Oglesby, son of a Civil War–era governor, sought the Republican gubernatorial nomination in 1920. Outside of Cook County, Oglesby won 84 counties and Small won 16. But with Mayor Thompson counting the votes in Chicago, and a favorable yet controversial ruling from the state board of elections, Len Small was declared the nominee a month before the election. (KPL.)

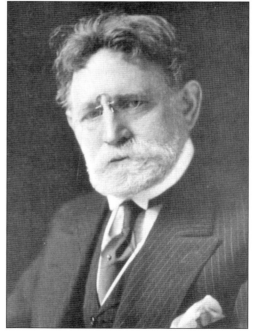

James Hamilton Lewis was the Democratic candidate. Lewis questioned whether Small was eligible to be governor since the constitution barred anyone who owed money to the state from holding statewide office. Others also raised the issue, such as the *New York Times*, which wrote on October 15, "Len Small's candidacy has impaired the true Republican principles of the state. By doing so, it has injected an element into the state election which stains the state Republican ticket." However, 1920 was a big Republican year, and Small was elected governor. (KPL.)

"Now followed an administration which for waste, mismanagement, inefficiency, intrigue, manipulation and downright disregard of the public interest has few parallels in the history of the United States," wrote Carroll Wooddy in 1931 in *The Case of Frank L. Smith*. Leslie Small, seen at right, worked as a teller in his father's bank until 1913, when he became editor of his father's newspaper. He later became publisher and kept the job until he died in 1957. Governor Small created the department of purchases and construction and put Leslie in charge of hundreds of millions of dollars in projects. Governor Small's son-in-law Arthur Inglesh became administrative auditor of the department of finance. Numerous family members and Kankakee cronies were on the state payroll. Below, the Small house is decorated for the 1920 campaign. (Both JR.)

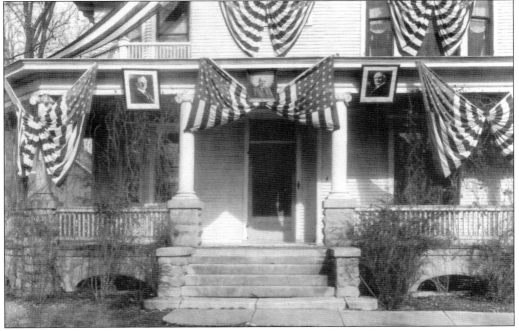

Adolph Marks was the Republican candidate for the state senate in Chicago's First District in 1922. A victory would give Governor Small a one-seat majority. Democrat Norman MacPherson won the election by 43 votes, and his victory was confirmed by the Chicago Board of Elections. But Governor Small had his state board of elections throw out enough votes to make Marks the winner. Republican attorney general Edward Brundage said, "They wanted that seat and they took it." Secretary of State Louis Emmerson agreed with him, but Marks stayed. (JR.)

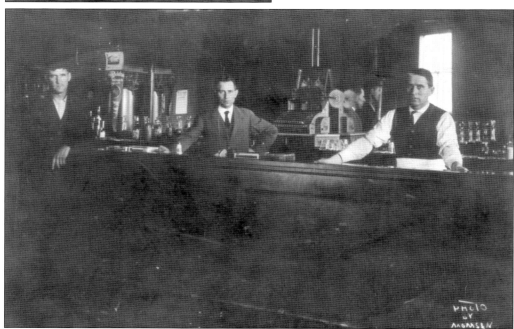

Prohibition did not end the saloon, it just drove it behind closed doors. This picture shows Rieck's Saloon in the small village of Campus, Illinois, between Chicago and Springfield. Prohibition helped spur corruption and crime throughout its time on the books. (Courtesy of John Ulrich.)

When Small became governor, he scrapped the Illinois Civil Service Commission and brought back the spoils system. State representative Truman Snell (seen here) said Small's aide Julius Johnson bribed legislators for votes. Johnson was forced to resign, and Small then appointed Johnson as Illinois Commerce Commission secretary—at a higher salary. (JR.)

State senator James Barbour sued Governor Small for slander in 1924. Barbour was a special prosecutor who helped convict mobster John Looney. Small accused Barbour of illegally being paid twice by the state, as a senator and as a prosecutor. Barbour said his fee came from a citizen's fund. Small said private money turned over to the state became state money—an interesting assertion from a man who did not think interest earned on state money in state bank accounts belonged to the state. Judge William Gemmill asked Small and Barbour to work something out, and Barbour dropped his lawsuit. (KPL.)

During Len Small's term as state treasurer from 1917 to 1919, he and state senator Edward Curtis operated a money-laundering scheme that netted them about $2 million. Small deposited half the state's money across 350 banks, and the other half he deposited in just one bank—a bank that did not exist. Curtis (left) owned Grant Park Trust and Savings Bank (pictured below). He set up a sham operation called the Grant Park Bank. This bank had no furniture, no vault, and no building. It existed only on paper for the purpose of defrauding the state. Curtis loaned money to the Swift and Armour packing houses at six to eight percent interest, paid the state two percent interest, and kept the difference for himself and Small. (Both JR.)

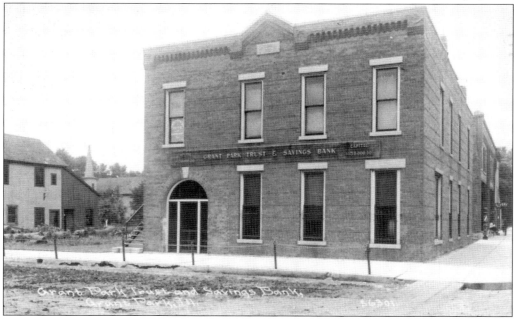

After Small's term ended, he continued the money laundering with his successor, Fred Sterling (pictured). Sterling named Small examiner of securities so Small could continue depositing money in a bank that did not exist. Sterling was elected lieutenant governor in 1920, and he was indicted with Small in 1921. Edward Curtis died on March 8, 1920. His timely death prevented him from being indicted; however, his brother Vernon was indicted. Illinois provided quite a spectacle—its governor and its lieutenant governor, both former state treasurers, were indicted for embezzlement, money laundering, and conspiracy. (KPL.)

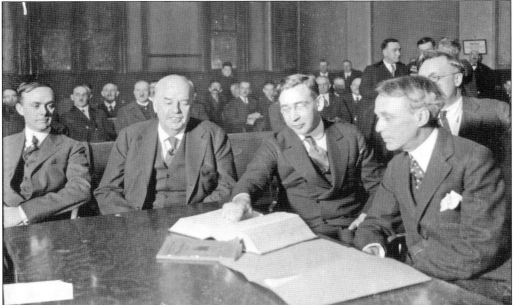

Governor Small went on trial for embezzlement. Pictured at the trial are, from left to right, Vernon Curtis, Governor Small, and lawyers Werner Schroeder and Charles LeForgee. LeForgee argued in court that Small did not steal the interest money from the state treasury because the money never went into the state treasury. (CHM-DN-0073738.)

The money laundering in the state treasurer's office under Small and Sterling ended when Edward Miller (seen here) became state treasurer in January 1921. As soon as he took office, Miller discovered what had been going on, and he went to Attorney General Edward Brundage for advice. A thorough investigation shocked Brundage, who asked, "Mr. Miller, do you realize that this is a criminal conspiracy to loot the public treasury?" (KPL.)

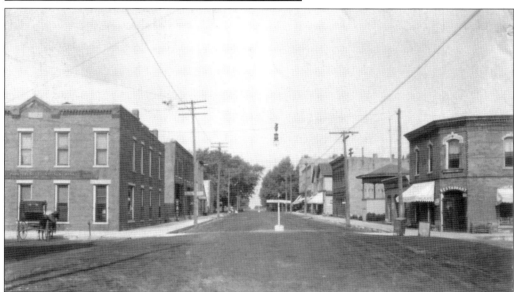

Grant Park is a tiny village in Kankakee County and not to be confused with the more famous Grant Park in downtown Chicago. Seen here is the village in 1917, with the legitimate Grant Park Trust and Savings on the left corner. (JR.)

Many newspaper writers and historians since 1921 have written that Attorney General Edward Brundage brought indictments against Len Small as revenge because Small cut Brundage's budget. However, the matter didn't start with Brundage. It started with Edward Miller, who brought the corruption to Brundage's attention upon becoming state treasurer. Brundage began his investigation in January 1921, and Len Small knew it. When Small couldn't persuade Brundage to drop the investigation, Small cut the budget so the attorney general's office would not have the funds for a special investigation. The budget cut came on July 8, while the indictments came on July 21. Because the budget cut came first, Small was able to argue that the indictment was revenge. And that has been the story written ever since. (KPL.)

Joseph Fifer, governor of Illinois from 1889 to 1893, was one of several lawyers representing the governor in 1921. Small's team of lawyers refused to allow Small to be arrested and advised him to evade the sheriff. They argued that for the judiciary to arrest an executive was a violation of the separation of powers. (KPL.)

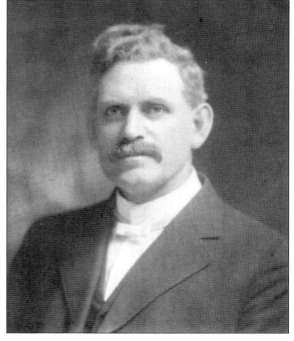

Former congressman James Graham also was on Small's legal team. He and Fifer argued in court that as governor, Len Small was above the law. Graham cited an old English doctrine that "the king can do no wrong," meaning the government could not commit a legal crime and thus should be given immunity to prosecution. Newspapers across the country were outraged at this legal defense; so was Judge Ernest Smith, who said there was no king in Illinois and ordered Small's arrest. (ALPLM.)

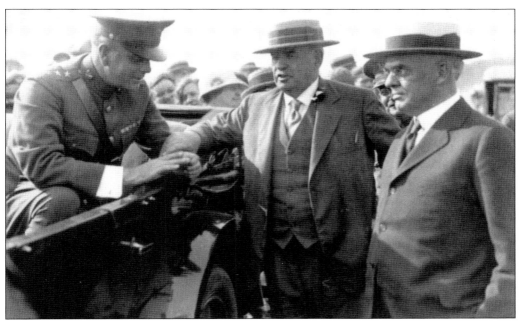

When Governor Small threatened to declare martial law in Sangamon County, he was not kidding. Above, General Somerall of the National Guard talks with Governor Small and Senator Deneen. Below, Governor Small poses with, from left to right, Generals Foreman, Somerall, and Black. (Both ALPLM.)

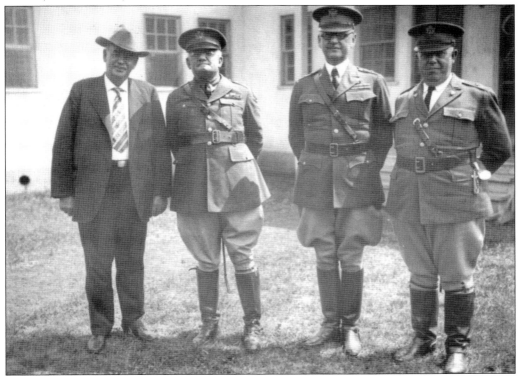

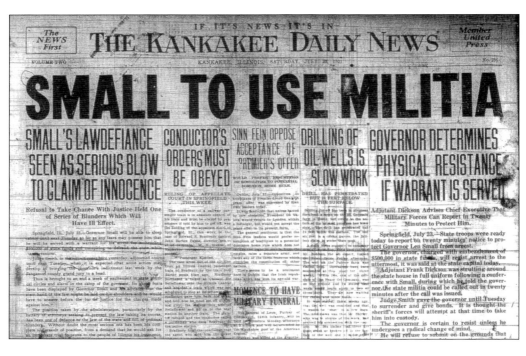

The *Kankakee Daily News* told all the details of the incredible series of events as Governor Small fought being arrested in 1921. The governor threatened to call the National Guard "with bayonets" to prevent the sheriff from arresting him, and he declared he had the immunity of a king. Small's rival *Kankakee Daily Republican*, however, did not let its readers know this part of the story. (Both KCC.)

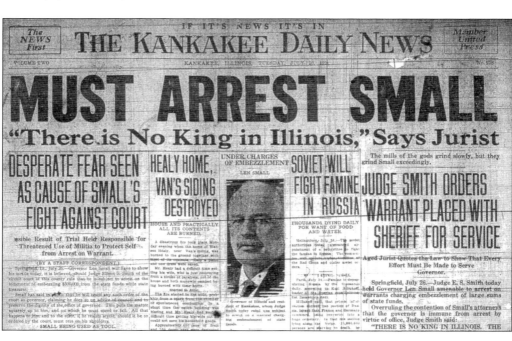

Sheriff Henry Mester arrested Governor Small in the governor's mansion on August 9, 1921. Small had spent three weeks running from the sheriff before he was trapped. The sheriff led the governor out past a crowd of reporters, photographers, and hundreds of citizens. After posting bond at the courthouse, Small went home. The *New York Times* reported, "He pulled his hat tightly down on his head and looked neither to the right nor the left as he strode through the lane of spectators which had been opened for his exit. There were no plaudits from the populace, who apparently realized that even a 'King' can be arrested, after all." (KPL.)

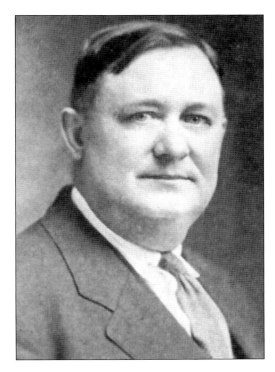

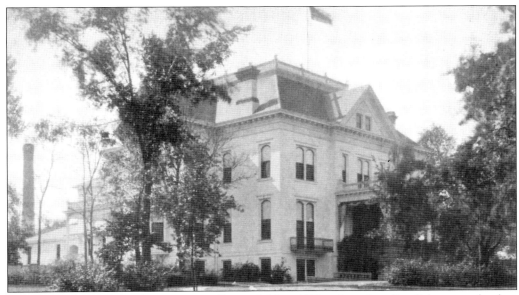

Pictured is the governor's mansion in Springfield in 1921, where Len Small became the first Illinois governor to be arrested in office. (KPL.)

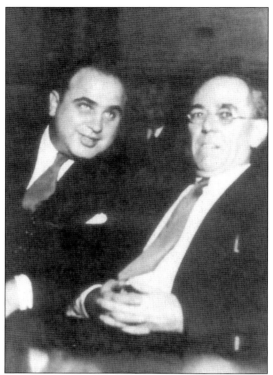

Len Small's lawyers did everything to delay and prevent the governor's case from coming to trial. They had Small run from the sheriff. They filed claims of immunity, motions to quash the indictments, challenges to the legality of the grand jury, and more. They finally won a change of venue from the state capital in Sangamon County to Waukegan in Lake County, which was the home of Fred Lundin. Waukegan also was close to Chicago, and it was easier for gangsters to fit in there than in rural downstate Sangamon County. One of Small's lawyers was Albert Fink, pictured here when he represented Al Capone. (KCC.)

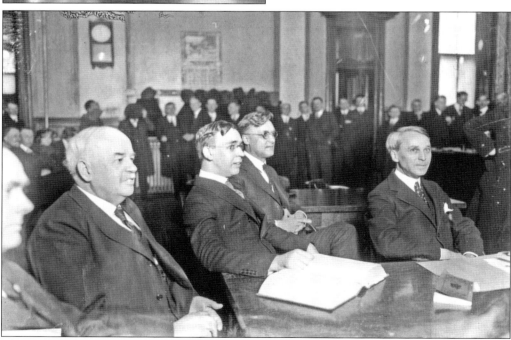

The anti-Small *Waukegan Daily Sun* began publishing pro-Small editorials, which were circulated across Lake County for all prospective jurors to read. After the trial, editor William Smith was appointed by Small to the Illinois Commerce Commission at a big salary. (CHM-DN-0073740.)

Roger Chapin, a probate judge, told how Small's agents posed as baking powder salesmen, going house to house and offering a free portrait of George Washington, Abraham Lincoln, or Len Small with each sale. By the reaction, the agents could tell whether the household was for or against Small. They used this information in selecting or eliminating jurors. (ALPLM.)

William Stratton (pictured), the Republican chairman of Lake County, helped with the change of venue and was part of the baking powder scheme. As a reward, Small created the department of conservation and named Stratton director. Stratton was elected as secretary of state in 1928. His son, also named William, was elected governor in 1953; in 1965 he was tried for tax evasion and was eventually acquitted. (KPL.)

The state subpoenaed the records of the Grant Park Bank, Grant Park Trust and Savings, and Len Small's First Trust and Savings Bank, but it did not receive any of these records. Louis Beckman, a cashier at Small's bank (and a future Kankakee mayor and state representative) testified that Len Small did not have an account at his own bank. (JR.)

At Small's trial in 1922, Norman Griffin, cashier for Grant Park Trust and Savings, testified that the records for his bank and the Grant Park Bank had been accidentally burned by the janitor in February 1921, just as the investigation was starting. Prosecutor James Wilkerson (pictured) could not believe it. He asked the whereabouts of the janitor. Griffin replied, "Uh, the janitor just died." (KPL.)

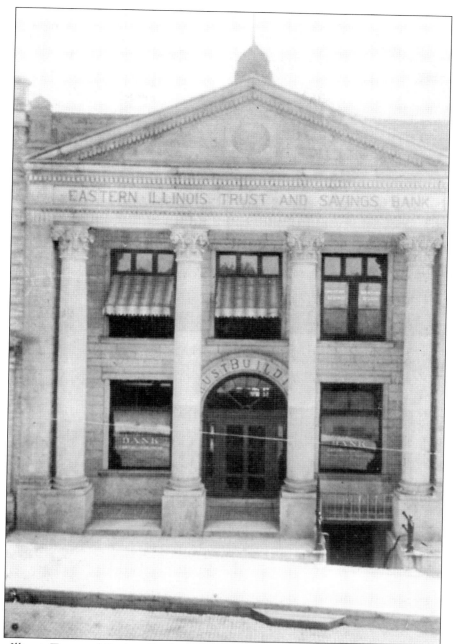

Eastern Illinois Trust and Savings Bank in Kankakee became First Trust and Savings Bank when Len Small took it over in 1916. Len Small was able to buy a bank, a daily newspaper, a huge farm, and make countless other investments with the money he acquired while on the public payroll. Just before Small was elected governor, the rival *Kankakee Daily News* observed on September 2, 1920, "Twenty years he has spent in public office, and during all that time has been of benefit only to himself. A single object from which he has never deviated is that of lining his pockets with gold. His rapacity and greed have always marked his work as a politician. He has never denied taking interest money which belonged to the state." (JR.)

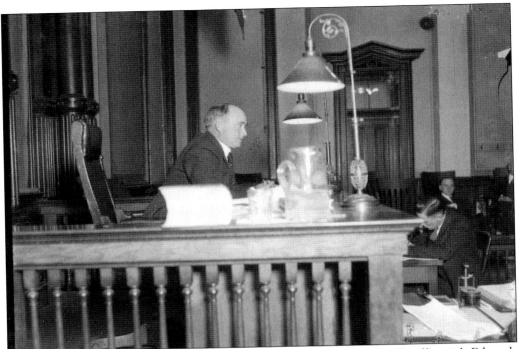

Judge Claire Edwards presided over Small's trial in Waukegan. After Small's trial, Edwards became a candidate for the Illinois Supreme Court. Small supported him, but he did not win. Edwards went back into private practice, and among his clients was George "Bugs" Moran. (CHM-DN-0073720.)

While the jury was deliberating, Small's newspaper reported he was "happy and laughing and confident" as he took his grandsons to a circus in Waukegan. It seemed he was not worried about the verdict. (KPL.)

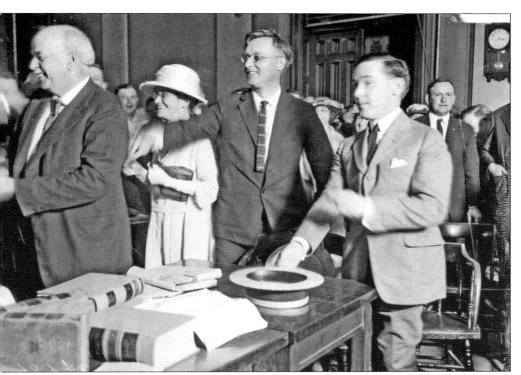

Len Small's trial began in May 1922. After six weeks, the prosecution rested, while Small's lawyers put on no defense. The jury came back quickly with a verdict of not guilty. The jurors did not look at one of the 7,000 pieces of evidence, and they had their bags packed before the trial ended. It soon was revealed they had been bribed. Here, from left to right, Governor Small, wife Ida, and son Leslie cheer as the verdict is read; the person on the right is unidentified. (CHM-DN-0074686.)

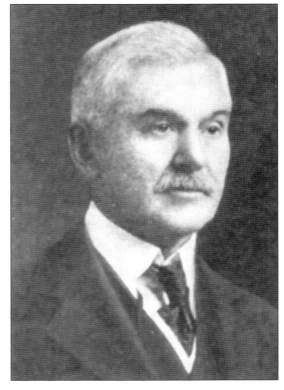

State senator Rodney Swift of Lake Forest condemned the baking powder salesmen, the *Waukegan Daily Sun* stories, Chicago gangsters, and the jury tampering. Swift said, "The meanest, most disreputable band of assassins ever gathered together was brought in. I saw them in the streets of my town, laughing and arrogant. They bribed one of our men. They paid one of our editors. They debauched our county. The report is that $100,000 went into Lake County." (KPL.)

Len and Ida Small drove home to Kankakee from Waukegan after his acquittal on Saturday, June 24, 1922. A victory celebration was waiting at their home. The governor and his wife shook hands for several hours. Then Ida said she wasn't feeling well, and she went inside and sat down. She had a stroke and slipped into unconsciousness. She never woke up, and she died on Monday morning. She was buried in the family plot in Mound Grove Cemetery in Kankakee. (At left, JR; below, CHM-DN-0074961.)

After the trial, eight jurors received state jobs. An investigation showed that gangsters intimidated and paid jurors. Chicago gangsters Eddie Kaufman and Eddie Courtney and juror John Fields went on trial; they were acquitted. Mobster and union boss "Umbrella Mike" Boyle (seen here) and hoodlum Ben Newmark (below) were called to testify about jury tampering. When they refused to talk, they were ordered jailed for contempt of court. Governor Small quickly pardoned them. Small then appointed Newmark a state fire marshal. (CHM-DN-0067691.)

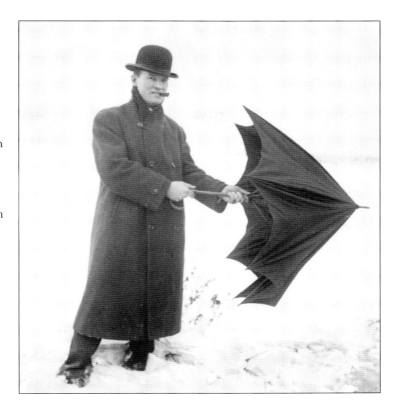

Newmark and Boyle were believed to have handled the money in the jury tampering. Also involved was Walter Stevens, called "the dean of Chicago gunmen" for the 60 murders he committed. In 1928, Newmark was killed by a shotgun blast through his bedroom window. The murder was never solved. (CHM-DN-0073676.)

This is the jury that acquitted Len Small, pictured with two bailiffs. John B. Fields, the only juror put on trial for fixing the jury, is second from the right in the back row. (Courtesy of Mary Haviland, daughter of John B. Fields.)

Just after bringing criminal indictments in 1921, Brundage filed a civil suit to recover the money Small embezzled. The Illinois Supreme Court (its building pictured here) ruled in 1925 that Len Small was liable and had to pay. The court also ruled that the Grant Park Bank was a sham. (KPL.)

Oscar Carlstrom was elected attorney general in 1924. He was friendlier to Len Small than Edward Brundage had been. Carlstrom was the machine's choice because he promised to go easy on Small in the civil suit. However, the wheels were in motion, and he could do little once it was in the hands of the judges. The courts ruled that Small was liable for $1.025 million, and Carlstrom bargained that down to $650,000. Small paid the sum, raising the money by docking the pay of state employees and shaking down road contractors. (KPL.)

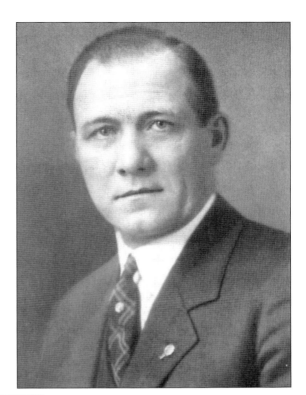

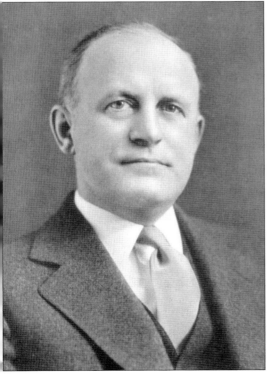

Otto Kerner Sr. (pictured) was elected attorney general in 1932 on the pledge he would have the Small settlement set aside and sue for more money, but the court would not allow it. Kerner's son married Helena Cermak, daughter of the late mayor. Otto Kerner Jr. was elected governor in 1960, was convicted on bribery and other charges, and went to prison. (KPL.)

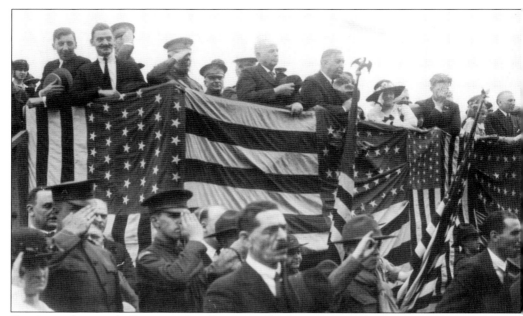

On the podium with Governor Small is Big Bill Thompson. With the Supreme Court ruling, Small's opponents sought to remove him from office, citing constitutional ineligibility. But Governor Small had his Republican majority introduce an amendment in May 1927 giving the present governor immunity from quo warranto removal. The legislature passed the amendment, and Small signed it, and this nullified the constitutional remedy. Small's lawyers now could argue that the constitution was unconstitutional. Len Small finally had written into law the fact that he was above the law. (KCMPC.)

Len Small stands in the center (above the two kneeling men) with a group of designated "Top Notch" Kankakee farmers. (JR.)

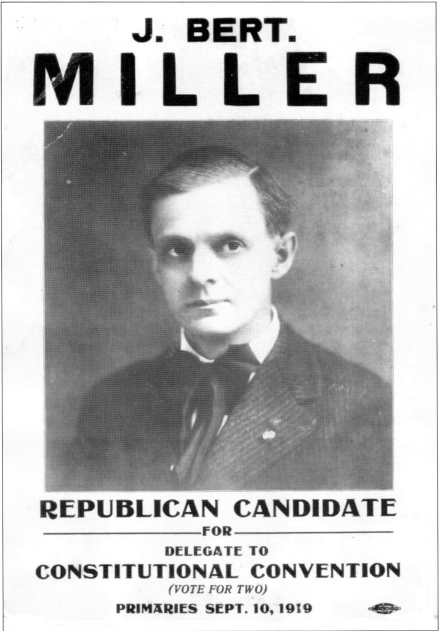

J. BERT.
MILLER

REPUBLICAN CANDIDATE
—FOR—
DELEGATE TO
CONSTITUTIONAL CONVENTION
(VOTE FOR TWO)
PRIMARIES SEPT. 10, 1919

State representative J. Bert Miller, a Republican from Kankakee, argued against the quo warranto amendment. He told the legislature, "No one knows him better than I. I have lived in the same town with him for 40 years, and if there is a bigger thief and political crook anywhere, I'd like to see the color of his hair." Part of Miller's impassioned speech was quoted in *Time* magazine, "Caesar had his Brutus, Jesus Christ had his Judas Iscariot, the United States had its Benedict Arnold and Jefferson Davis, and Illinois has Len Small. And if the Judas of Illinois had the courage of the Judas of Jesus, he would return the 30 pieces of silver, get a rope and hang himself, and remove the withering blight which will remain upon this state as long as he is governor of Illinois." (JR.)

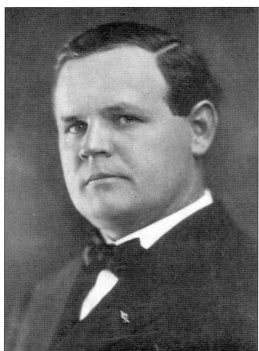

Clyde Stone was one of the justices who ruled against Small. When Stone ran for reelection in 1927, Small put up Speaker of the House Robert Scholes against him. The governor also awarded state contracts to businessmen who were delegates at the state convention to pressure delegates to deny Stone renomination. When Justice Stone was renominated, Small then tried to decertify the nomination. The Supreme Court overruled the governor. Stone was reelected and served on the high court until his death in 1948. (JR.)

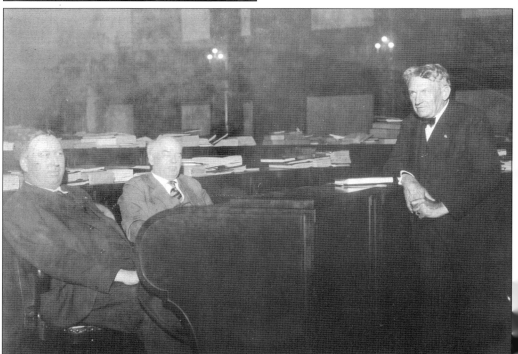

From left to right, state representative Reed Cutler, Governor Small, and state representative Robert Scholes are pictured conferring. Cutler supported the amendment to prevent Small's removal, saying the court did not have the right to remove someone elected by the people. (KCMPC.)

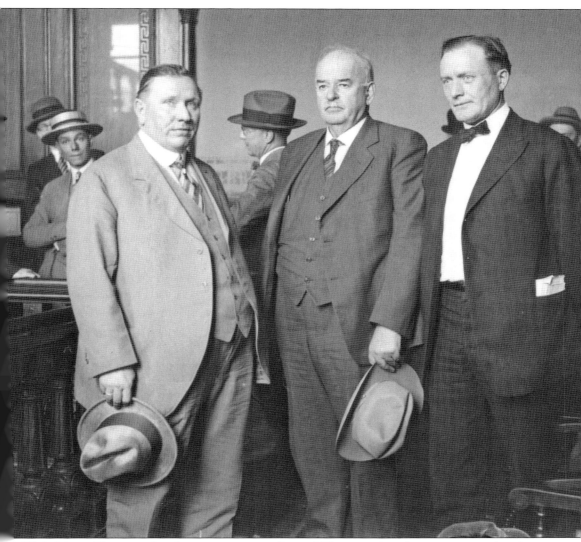

With Mayor Thompson's police on gang payrolls, and Thompson's wide-open town policy for gangsters and bootleggers, organized crime was further aided by Governor Small's pardon and parole policy. Small's pardons had been scandalous from the beginning. The matter blew up into a huge scandal in 1926, when it was revealed the Small administration had been operating a pardon mill. For a price, anyone could buy his or her way out of the penitentiary. Spike O'Donnell and Bugs Moran paid their bribes and were able to get their gangs back together to commit more mayhem on the streets of Chicago. The scheme was headed by Will Colvin (left), supervisor of paroles, and Chauncey Jenkins (right), director of prisons. They are pictured here with Governor Small during Small's trial in Waukegan. (CHM-DN-0080819.)

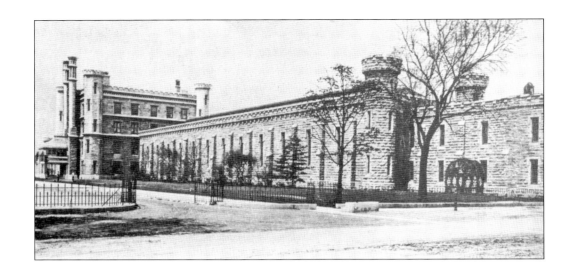

The pardons for bribes scandal broke in 1926 when Charles Duschowski, a Kankakee murderer, broke out of the state prison in Joliet (above) with five other prisoners after murdering assistant warden Peter Klein. It was revealed that the escapees were desperate because they did not have the money to bribe their way out as so many others did. Duschowski and other prisoners nearly got away twice in escape attempts from the Will County Jail in Joliet (below). Duschowski and two others were hanged in the jail yard in downtown Joliet on July 14, 1927. A third escapee, Charles Shader, was hanged there on October 10, 1928. Shader was the last convict executed by hanging in Illinois, as the electric chair replaced the rope in future executions. (Both JR.)

Will Colvin, chairman of the pardons and paroles board, boldly solicited bribes. Mrs. F. J. Haveland told a grand jury investigating the scandal that Colvin asked her for money if she wanted her son paroled. Governor Small also testified before the grand jury. The scandal became so hot that Colvin was forced to resign. Small then appointed him to the Illinois Commerce Commission at a high salary. (ALPLM.)

Ignatz Potz was hauling a carload of hooch for Torrio-Capone in 1922 when he shotgunned a pursuing police officer. He pleaded guilty and was sentenced to death. Governor Small stopped the execution and later gave Potz a complete pardon. Commenting on the Potz story in its July 12, 1926 issue, *Time* magazine wrote that Small was "a governor whom decent thousands regard as a cold-blooded crook." (JR.)

Cook County state's attorney Robert Crowe said, "Perhaps the worst handicap this office confronts is Len Small's pardon and parole system. He lets them out as fast as we put them in." Capone biographer Robert Schoenburg wrote, "Len Small's gubernatorial pardons made him, in effect, Johnny Torrio's recruitment and personnel officer." (KCC.)

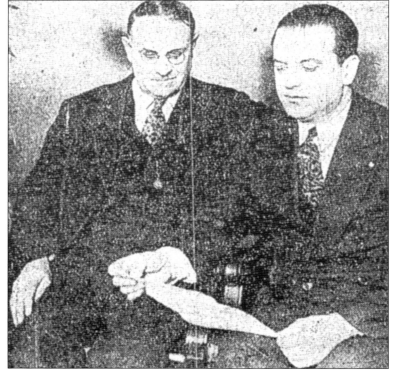

This grainy newspaper clipping is the only known photograph of Michael Messlein (left), who is conferring with his attorney Albert Sabath before a grand jury investigating the pardon mill. Messlein, Colvin, and Jenkins operated the scheme. Messlein, the middleman between convicts and Colvin, admitted that more than 8,000 pardons and paroles were sold by the Small administration. (JR.)

Frank "The Enforcer" Nitti took over the Chicago Mob after Al Capone was sent to prison. Capone said in a 1927 interview, "There's one thing worse than a crook, and that's a crooked man in a big political job. A man who pretends he's enforcing the law and is really making dough out of somebody breaking it." Regarding specific politicians, Capone added, "There are worse fellows in the world than me." (KCC.)

From left to right, Three-Finger Jack White and Red Barker are seen with lawyer Michael Ahern and Al Capone. White and Barker bought pardons from Governor Small. After Judge Shurtleff freed Fur Sammons, White hired Sammons as a machine gunner for Frank Nitti. Sammons murdered a Teamsters vice president and another man before being sent back to prison. (KCC.)

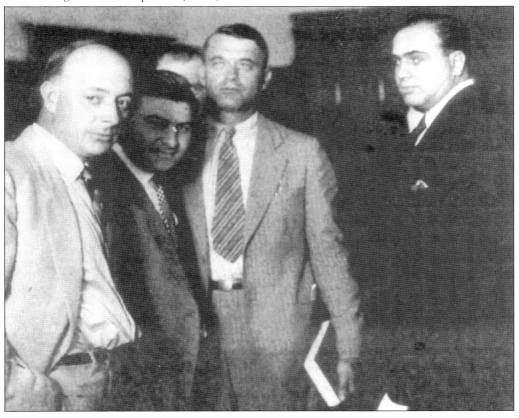

The bloodiest Mob wars of the Roaring Twenties were over control of beer territories. One war started in 1923, and it was Gov. Len Small who got it started. The governor did this by letting bank robber Edward "Spike" O'Donnell out of prison by commuting his sentence, making him eligible for parole. The commutation came through Umbrella Mike Boyle, Capone's friend and Governor Small's Mob contact, who arranged many of the pardons and paroles for criminals. Small was repaying Boyle for his help with his acquittal in the governor's corruption trial. (KPL.)

State senators Edward J. Hughes (left) and Frank J. Ryan (right) were among 14 politicians who signed a petition for Spike O'Donnell's parole. O'Donnell was released into the custody of Ryan. Hughes later was Illinois secretary of state from 1933 to 1941. (Both KPL.)

Spike got his gang together and went into business with Packey McFarland, owner of the Porter and Joliet Citizens Breweries in Joliet. McFarland, a former prizefighter, had been bootlegging for years. Packey avoided prosecution after he and his brother Tom were arrested in 1922 and Tom took the rap and a six-month jail sentence. Federal judge James Wilkerson ordered the Porter Brewery seized in 1923. Tom was arrested and Packey denied involvement. The brewery started back up, and Wilkerson again seized it in 1924. After Prohibition was repealed in 1933, the breweries were back in business, with Packey in charge. Below, Packey is seated next to his wife, Margaret, in front of their Joliet home around 1920. Standing to the left are his brother Tom McFarland and Margaret's sister Agnes Brady. (Both JR.)

71

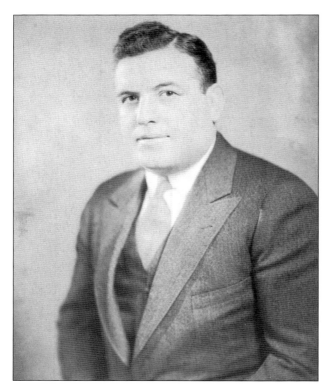

Packey McFarland's record as a prizefighter was 104 wins, 1 loss, and 6 draws. (He also was the great-uncle of author.) McFarland died on September 23, 1936. His funeral at St. Raymond's in Joliet brought thousands of people, including Gov. Henry Horner. Below are Packey's mother-in-law, Sarah Loughran, and his children, (from left to right) Sarah, Margaret, Miriam, and Patrick Jr. (Both JR.)

Mona Marshall was drugged, kidnapped, and sold to a house of prostitution called the Casino Saloon in 1907. It was owned by Big Jim Colosimo and run by Harry Guzik. When Mona finally escaped, her case was the one that brought the words "white slavery" into popular use; it was also one of the cases that resulted in the passage of the federal Mann Act in 1909. Harry Guzik later ran the brothels for Johnny Torrio and Al Capone. (CHM-DN-0005023.)

Harry (pictured) and Alma Guzik managed the Roemer Inn brothel in Chicago for Johnny Torrio and Al Capone. In 1921, they advertised for a maid. Minnie Oehlerking answered the ad and was forced into prostitution. After several months as a captive, Minnie was rescued. The Guziks were convicted on pandering (white slavery) charges and sentenced to a year in prison. They went to Johnny Torrio, who sent men to Governor Small. Before the Guziks spent one day in jail, Governor Small pardoned them. The Guziks were back in the prostitution business for Torrio and Capone a short time later. (KCC.)

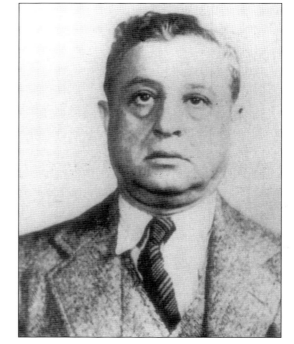

Pictured here is Harry Guzik's brother Jake. Jake was Capone's bookkeeper, and he was said to be the only man Capone trusted. Both Harry and Jake had the nickname "Greasy Thumbs." (KCC.)

State representative Lee O'Neil Browne represented Guzik before the pardon board. Judge Harry Fisher, who sentenced the Guziks, refused to sign Browne's letter to Small requesting a pardon. The state was not notified of the hearing and thus did not send anyone to object. Also appearing before the pardon board on Guzik's behalf was state representative Thomas O'Grady of Chicago. O'Grady (below left) also had signed a petition urging Spike O'Donnell's release from prison. Chauncey Jenkins (below right) was Small's director of public welfare and prisons. He helped explain the governor's pardons, including the Guzik pardon. Jenkins also was involved in the pardon mill. (All JR.)

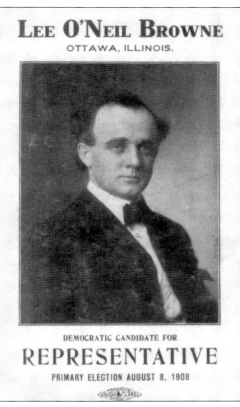

LEE O'NEIL BROWNE

OTTAWA, ILLINOIS.

DEMOCRATIC CANDIDATE FOR

REPRESENTATIVE

PRIMARY ELECTION AUGUST 8, 1908

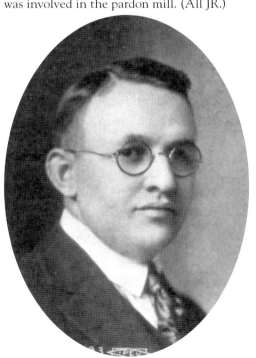

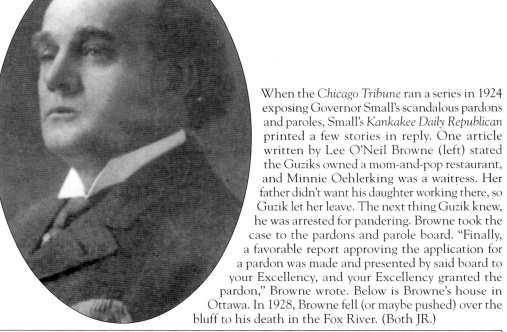

When the *Chicago Tribune* ran a series in 1924 exposing Governor Small's scandalous pardons and paroles, Small's *Kankakee Daily Republican* printed a few stories in reply. One article written by Lee O'Neil Browne (left) stated the Guziks owned a mom-and-pop restaurant, and Minnie Oehlerking was a waitress. Her father didn't want his daughter working there, so Guzik let her leave. The next thing Guzik knew, he was arrested for pandering. Browne took the case to the pardons and parole board. "Finally, a favorable report approving the application for a pardon was made and presented by said board to your Excellency, and your Excellency granted the pardon," Browne wrote. Below is Browne's house in Ottawa. In 1928, Browne fell (or maybe pushed) over the bluff to his death in the Fox River. (Both JR.)

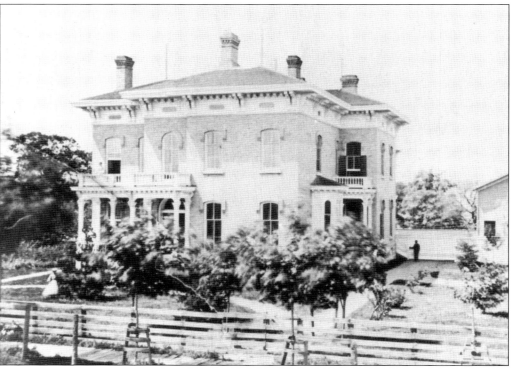

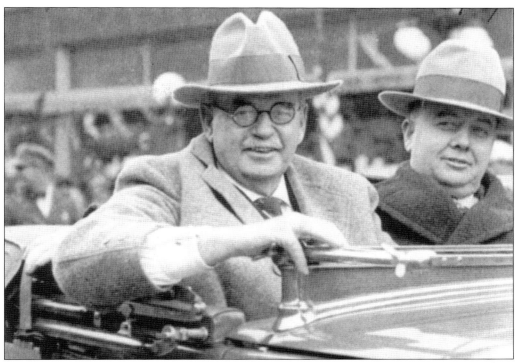

Governor Small and Prophetstown mayor George Bryaia are pictured above in 1927. Below, Governor Small addresses a crowd in Quincy in 1926. (Both ALPLM.)

Frank Leslie Smith was appointed by Governor Small as head of the Illinois Commerce Commission in 1921. Smith used his position to shake down the heads of the utility companies he was regulating (including taking $125,000 from Samuel Insull). Smith used that money to run for the U.S. Senate in 1926, which he won. But the Senate decided that Smith bought his seat by corrupt practices, and it refused to admit him. Missouri senator Jim Reed, who chaired the hearings, said, "If this man is to be seated, let us hang over the door of the Senate, 'Seats For Sale.'" (Both Dwight Museum.)

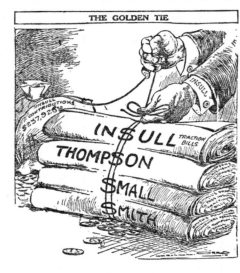

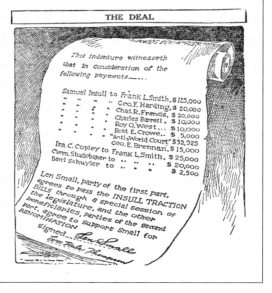

Col. Smith started his own bank in 1905 called the Frank L. Smith Bank. He always called himself "Col. Smith," but he was one of many given an honorary title of "colonel" by Gov. John Riley Tanner as a reward for political work; Smith was never in the military. Col. Smith coveted the governor's office for decades. He ran for office numerous times but won just one term in Congress. A biographer called Smith "a third rate aspirant for first class honors." A campaign sign for Smith is seen below during a 1926 snowstorm. Edward Litsinger in 1927 said Thompson, Small, and Smith were the Three Musketeers, and "the right way to pronounce it is the Three-Must-Get-Theirs." (At right, KPL; below, courtesy of Paul Roeder, whose father Herman was Smith's chauffeur for 20 years.)

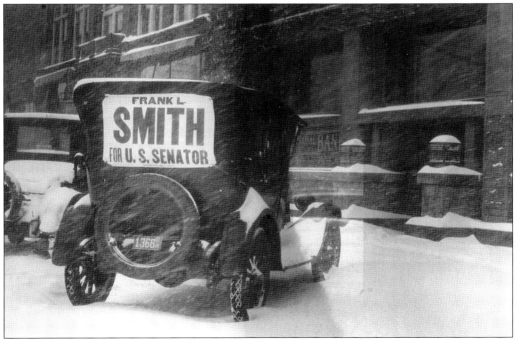

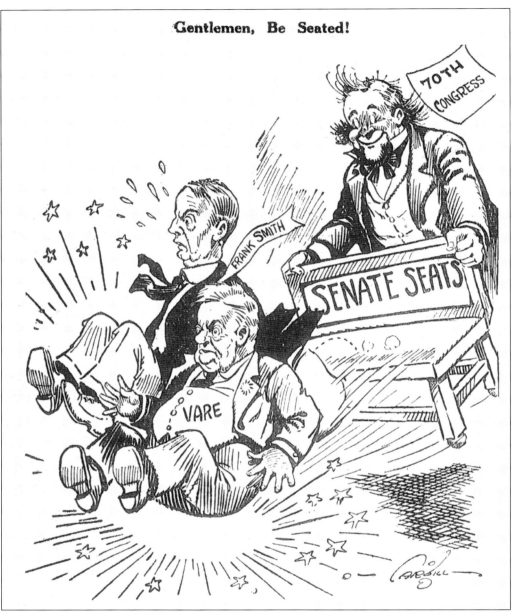

Gentlemen, Be Seated!

Along with Frank L. Smith, Pennsylvania senator William Vare also was booted from the Senate (for Mob connections). In the *Illinois Blue Book* list of U.S. senators, there is an asterisk beside only two names: William Lorimer, who was elected and kicked out, and Frank L. Smith, who was elected and denied his seat. (KPL.)

The Ku Klux Klan experienced tremendous popularity in the 1920s posing as a group that would fight vice and restore virtue to America. It drew millions of new members all across the United States, and many politicians attached themselves to this surging group. Governor Small accepted the endorsement of the Klan in 1924, 1928, and 1932. The Klan claimed credit for Small's reelection in 1924. A *Chicago Tribune* report in 1923 found numerous Klansmen in state government, including Small's personal secretary. (Both ALPLM.)

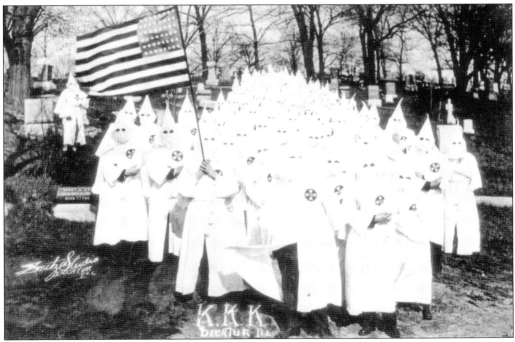

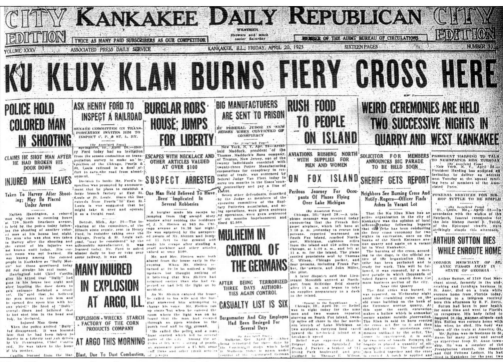

The Klan opened a chapter in Kankakee in 1921. It had cross burnings all across Illinois and three in Kankakee in April 1923. Below are a few members of the Joliet Klan chapter. Governor Small had a long list of enemies, topped by the *Chicago Tribune*. But Al Capone and the Ku Klux Klan were not on the list. (Both JR.)

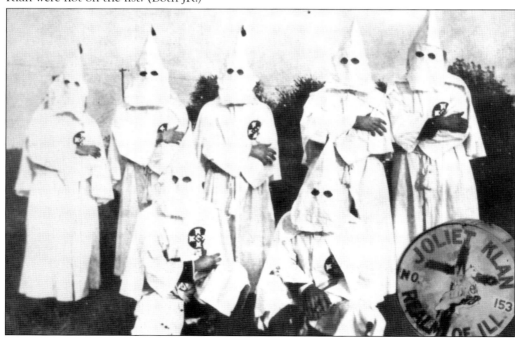

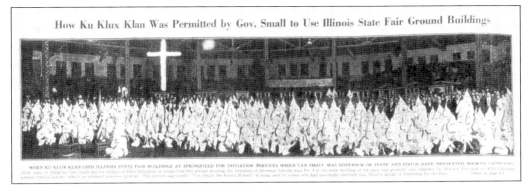

This clipping was in the *Chicago Tribune* on April 7, 1928. It reads, "When Ku Klux Klan used Illinois State Fair buildings at Springfield for initiation services when Len Small was governor of state and could have prevented masked gatherings. After years of denials by Governor Small and his cabinet of Klan affiliations, this picture showing the initiation of Abraham Lincoln Klan No. 1 in the main building at the state fair grounds was obtained by William Harrison of 4353 Vincennes Avenue, colored lawyer, who is an assistant attorney general. The picture, captioned 'Len Small, the Klan's friend,' is being sent to voters who previously received Governor Small's denial of friendship for the Klan." (Above, *Chicago Tribune*; below, Dwight Museum.)

KKKK

Knights of Ku Klux Klan
OPEN AIR MEETING
2 Miles South of
PONTIAC, ILL.

Fri. Eve., Aug. 14

Band Concert at 7:30 P. M. by 35 Piece Band
Singing by Male Quartette
EXCELLENT SPEAKING
by the REV. APPLEGATE, of Decatur, Ill.
Plenty of good seats
Everyone Invited Regardless of Color, Creed or Sex
Refreshments Served On Grounds

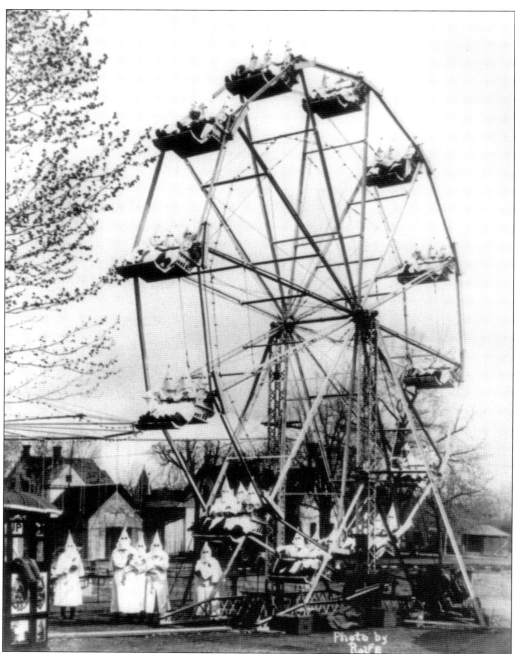

The *Tribune* quoted William Harrison, "Len Small, you know that the Ku Klux Klan despises the people of our race and has despised, whipped, lynched, mutilated and murdered our people during all the years since the broken bodies of our forefathers dripped blood in the wake of the night-riding Klan. Len Small, now you ask the Negro vote. How dare you do so? Look at the picture and answer us. How dare you ask the citizens of our race to vote for you, the friend and ally of the Ku Klux Klan?" This bizarre picture shows the hooded hoodlums enjoying a day at the fairgrounds. (ALPLM.)

The legislature called Small to testify in 1923 about allowing the Klan to use state facilities, such as the state fairgrounds, the Chicago armory, and the Springfield arsenal, for their robe initiations and cross burnings. Small denied being a Klansman. Albert Livingstone, the secretary of the senate, said the Klan barred no one on account of religion or race. State representative Adelbert Roberts (seen here), an African American Republican from Chicago, shot back, "I am an American citizen and a college graduate. Please bring me an application for membership in the Ku Klux Klan tomorrow." (KPL.)

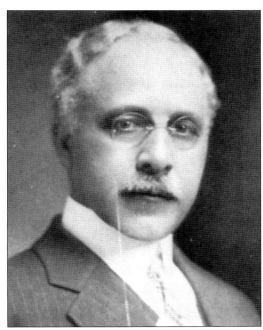

Small's Democratic opponent in 1924 was Judge Norman Jones, who claimed the Klan was openly working for Small. He said, "The Ku Klux Klan has made itself an issue in this campaign, not only by openly defying the Constitution of the United States but by injecting itself into politics in support of the reelection of its friend and aide, Gov. Len Small. We want no Klan-ruled state in Illinois." Jones lost to Small in 1924. Jones served as a justice on the Illinois Supreme Court from 1931 until his death in 1940. (KPL.)

One of the most infamous tragedies in Illinois history is the Herrin massacre in 1922. During a coal strike, owners of the Herrin mine hired strikebreakers. An armed mob of union miners captured the strikebreakers and slaughtered 20 of them. (JR.)

This tragedy did not happen overnight. The strike was called on April 1, the strikebreakers arrived June 15, and the pot boiled until the massacre on June 22. National Guard colonel Samuel Hunter was there, and he reported to Governor Small and Gen. Carlos Black (above). But Governor Small did not send National Guard troops, as he was on trial for embezzlement at the time. Two days after the Herrin massacre, the jury found Governor Small not guilty. (JR.)

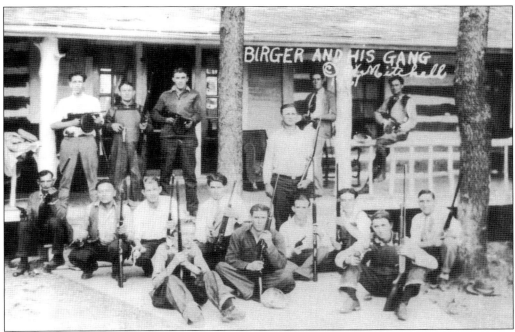

When the Ku Klux Klan took over parts of southern Illinois, local officials asked Small for National Guard troops. Small told them, "If you want the law enforced, go back and elect someone that will enforce the law." It was taken as carte blanche by the Klan to do as it pleased. The reign of terror by Klansmen vigilantes brought beatings, gun battles, and two dozen murders. Also terrorizing southern Illinois were gangs led by Charlie Birger and the Shelton brothers, which mirrored the vice and violence of gangs in Chicago. Birger was hanged in 1928 for the murder of the mayor of West City. (Both KCC.)

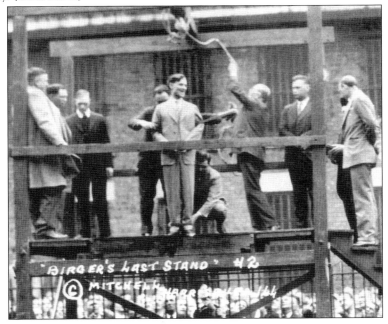

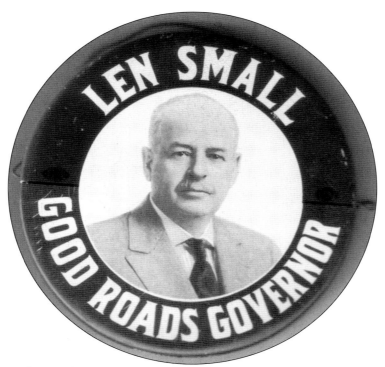

Small's legacy is the "good roads governor" who "pulled Illinois out of the mud." The picture below shows rural roads that were muddy in wet weather, snowy and icy in the winter, and rutted in dry weather. Len Small had the good fortune to take office at a time when the automobile was coming into an era of mass popularity and hard roads were being built across the nation. (Above, JR; Below, *Illinois Blue Book*.)

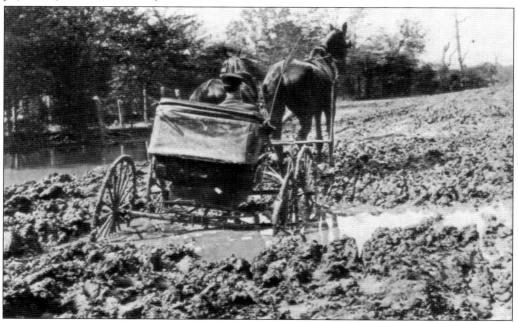

It was Gov. Frank Lowden who got the state highway-building program going with a $60 million bond issue in 1918. Governor Small took more credit than he deserved. Small built 6,809 miles during eight prosperous years of the 1920s, while his successors built 8,109 miles during the next seven lean years of the Great Depression. (KPL.)

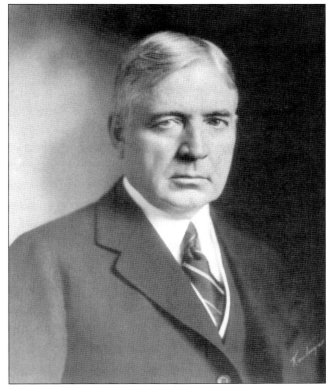

This 1925 *Illinois Blue Book* image shows roadwork near Marion. Governor Small used the roads program as a political weapon, building roads where he had support and denying them where he had little support. He told voters they better vote for him if they wanted roads. And he said road building would cease if he were not reelected. However, they would have been built no matter who was governor. (KPL.)

Gov. Small's administration was filled with crooks. W. H. H. Miller, director of the Illinois Department of Registration and Education, sold a thousand fraudulent medical, dental, and pharmaceutical diplomas to people who couldn't pass the exam. As he was booted from office, he took a stack of blank diplomas and the official seal and continued selling. He ended up going to prison. William Malone, chairman of the Illinois Tax Commission, stole $59,574 in income taxes and took $330,000 in payoffs from corporations. He also went to prison. Clifford Sawyer, a state representative from 1921 to 1927, was appointed to the parole board in 1927. Sawyer and his son Thomas were on the Kankakee Park Board and were indicted in 1936 for selling land they owned to the park district at inflated prices and for stealing funds from the estates of widows and orphans. Both men spent the rest of their lives on the lam from the FBI. Clifford fled with his wife to California, where he married a wealthy widow named Edith, who didn't know he already had a wife. Edith (second from the left) and Clifford (fourth from left) are pictured in a studio where *Lydia Bailey* was being filmed in 1951. (Courtesy of Nancy [Sawyer] Wagner.)

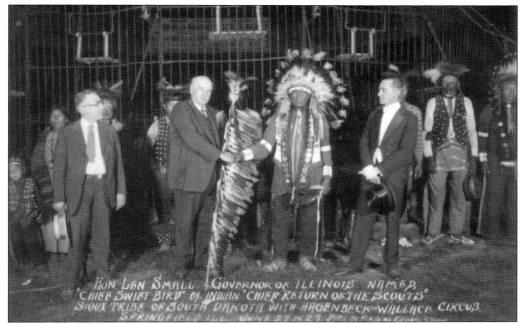

Governor Small was made a tribal chief and adopted brother of the Sioux Indian Nation in 1927. He was given the name Chief Swift Bird. "He is, to them, the reincarnation of a departed chieftain, who once ranked high in their tribunals," the Small-owned *Kankakee Daily Republican* newspaper reported. However, this title was bestowed by "Indians" from a touring circus as a publicity stunt for their Springfield appearance. O. D. Odom, manager of the circus, praised Small for his road-building program, which meant his wagons could travel more miles to more engagements. (ALPLM.)

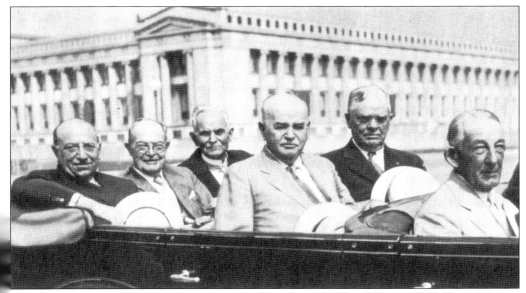

From left to right, six Illinois governors appeared at Chicago's World's Fair in 1933: Henry Horner, Edward Dunne, Joseph Fifer, Len Small, Charles Deneen, and Louis Emmerson. (KPL.)

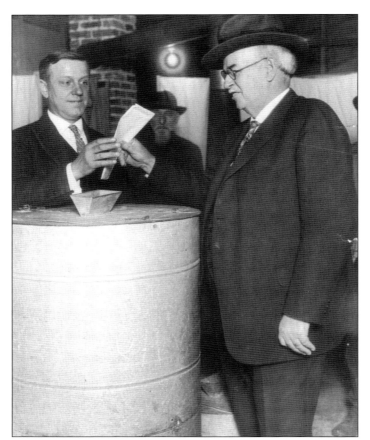

Governor Small is seen voting in Kankakee. The rival *Kankakee Daily News* editorialized on July 21, 1921, "His leadership constantly kept the party embroiled in factional strife. A 'rule or ruin' policy was his favorite method, and his tactics drove the better element of the party from his leadership until he was able to hold in line only those who profited personally in acknowledging his kingship." (KCMPC.)

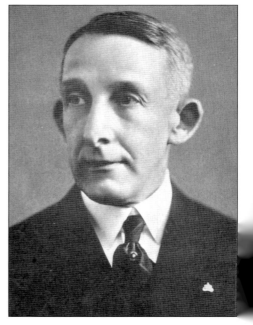

In 1924 and 1928, the Republican Party sought a man who could beat Small for the Republican nomination. In 1924, they chose state senator Thurlow Essington; he did not win. However, the party succeeded in 1928 when Secretary of State Louis Emmerson beat Small in the primary. Emmerson was popular, and the public was finally fed up with Len Small. Emmerson was elected, and when he entered the governor's mansion in January 1929, he found that Small had stolen the silverware and several truckloads of other valuables. (KPL.)

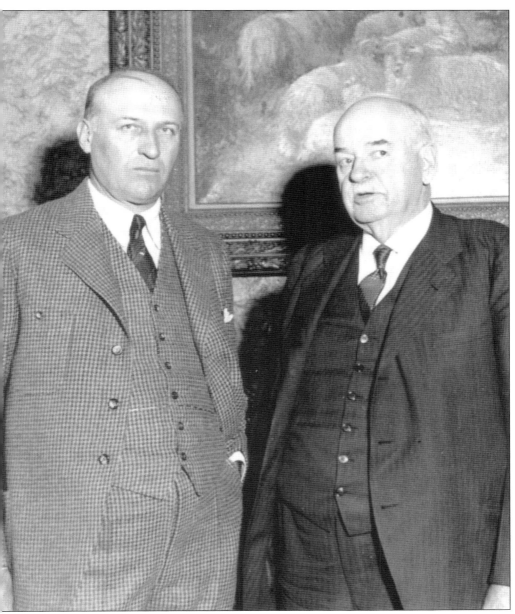

U.S. senator Otis Glenn poses with fellow Republican Len Small. Glenn was elected senator in 1928, defeating Anton Cermak. Referring to Small's royal claim in 1921, Glenn said, "The ruler of Illinois is King Len, the Small." Before the gubernatorial primary in April 1928, Glenn said, "By all means, give Small another term. But we may disagree as to where he should serve it." Commenting on Governor Small in its July 16, 1921, edition, the *Kankakee Daily News* wrote, "Some men go into politics with the idea of leaving footprints on the sands of time. And others are lucky if they get out without having their thumbprints taken." (ALPLM.)

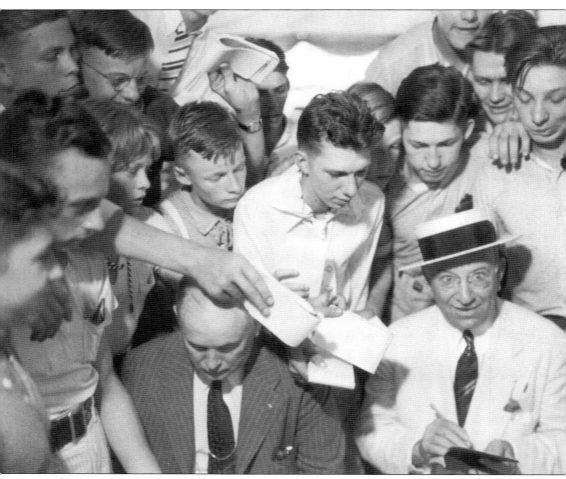

Gov. Henry Horner is in the Panama hat, signing autographs. Horner defeated Small for governor in 1932. Campaigning in Kankakee, Horner mentioned the Grant Park Bank, state jobs for jurors, and the pardons, "You know the shameful story of the pardon for Harry Guzik and his wife Alma, convicted as panderers and white slavers, and freed by Small because of the political influences wielded by Al Capone and his chief lieutenant, Jack Guzik. You know the story of other criminals pardoned by Small, not by scores but by hundreds. You even know that when Small left the executive mansion, the $25,000 silver set that had been donated by former Gov. Lowden was not found by Gov. Emmerson, and you know that it has not been returned." (ALPLM.)

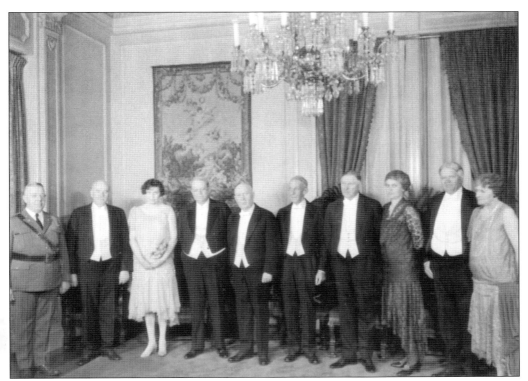

Pictured above from left to right on New Year's Eve 1923 in the governor's mansion are Gen. Carlos Black, Governor Small, Ida May Inglesh, Lt. Gov. Fred Sterling, Speaker of the House David Shanahan, Secretary of State Louis Emmerson, treasurer Oscar Nelson and wife, and superintendent of public instruction Frank Blair and wife. Below, Small relaxes with friends at the Sims Ranch in Michigan in 1927. (Both ALPLM.)

Small frequently railed against rich tax dodgers. But the *Chicago Daily News* discovered Small declared to the assessor in 1920 only three Holstein cows valued at $90 when he really owned 50 cows worth $20,000. Pictured here is part of the herd on his Kankakee farm. Small also swore to having just $1,000 in the bank and personal property totaling $4,485. And Small paid no income taxes on the interest money from the Grant Park Bank, leading the newspaper to ask, "Who are the rich tax-dodgers?" (JR.)

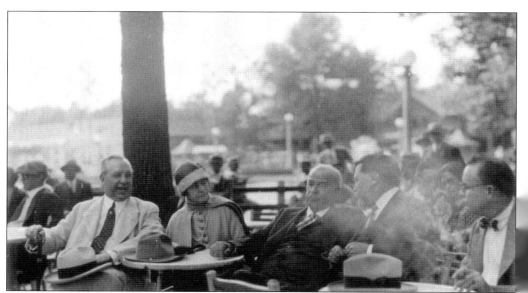

Pictured here from left to right are Sandy and Mrs. Fyfe, Governor Small, Dr. John Dill Robertson, and Ike Volz. (ALPLM.)

Gov. Len Small is pictured at right with his grandson Len H. Small in the 1920s. Len H. became publisher and built the Kankakee Republican Printing Company (now Small Newspaper Group) into a chain of respectable newspapers. Below, Governor Small signs a bill. (At right, ALPLM; below, KCMPC.)

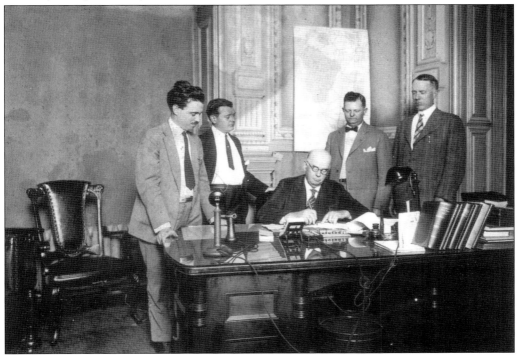

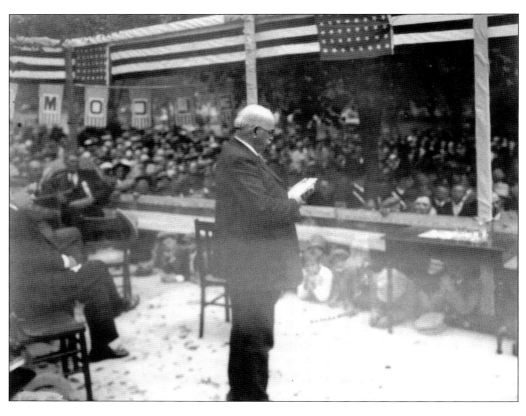

Governor Small is seen here addressing a crowd and enjoying a ball game with Mayor Thompson. (Both ALPLM.)

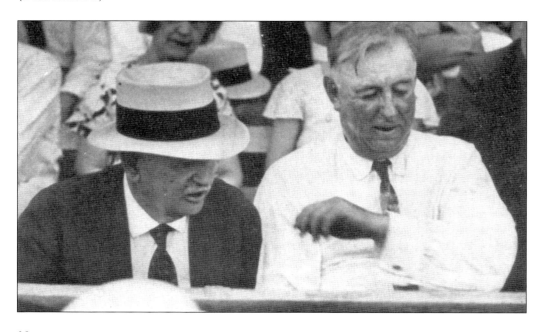

Small poses above at a bill signing in 1928. Below are, from left to right, Big Bill Thompson, Sen. William E. Borah of Idaho, Len Small, and Sen. C. Wayland Brooks. (Both ALPLM.)

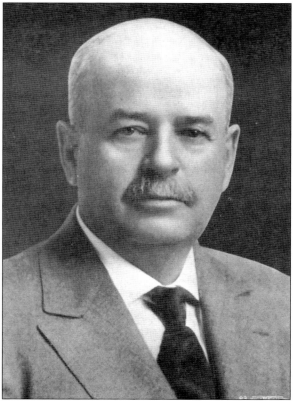

Pictured above from left to right are Leslie Small, his wife Grace, son Burrell, Governor Small, Ida May Inglesh, Arthur Inglesh, and Len H. Small. At left is the official portrait that Governor Small used continuously for the last 20 years of his life. (Above, ALPLM; at left, JR.)

Four

THE GOVERNOR
AND THE COLONEL
PUBLISHERS AND PARTISANS

Len Small hated the *Chicago Tribune,* and the *Tribune* returned the feeling. Here is an excerpt from an April 5, 1923 editorial:

> Len Small was made governor by Thompson and Lundin when their control over Chicago was tightest. Small is even worse than either Thompson or Lundin. He has always been bad. Twenty-five and thirty years ago, his connection with the corruption of public institutions such as the Kankakee insane asylum was notorious. He always has been notorious.
>
> Temperamentally, he is timid, but he is so unscrupulous that his lack of principle gives him the appearance of audacity. When he was shaking in his boots for fear a Lake County jury would send him to the penitentiary, he was amazing some of the stoutest rascals in the state by his boldness in offering voters the bribe of good roads in exchange for legislators who would protect him.
>
> He is not guided by courage, shrewdness or strength, but by his lack of principles. He is stupid, and his stupidity plus his indifference to public decency allows him to do the outrageous things for which any governor ought to be impeached.
>
> He was a public nuisance when he was a little grubbing downstate politician, picking up offices which would allow him to control coal contracts for an institution, levy an assessment on poorly paid institution employees, and gather in nickels and dimes where he could find them.
>
> He had been a small minded, realistic gangster, but aping Thompson, he tried to be a flannel-mouth and to spout phrases regarding the people and the profiteers.
>
> His whole political life has been one of profiteering at the expense of people who pay taxes, and even now he is trying to dodge a civil accounting for $2,000,000 of interest on public money which disappeared while it was in his hands. Until Mr. Small remembers where it went, we are entitled to believe that a careless janitor burning up bank records did Mr. Small a great favor, and made it greater by conveniently dying.
>
> Wherever Small puts his hand, he leaves a black spot. This unprincipled governor, in his stupidity which appears as audacity, is now bulldozing the state. It seems to be easy if an unscrupulous man tells a county it must stay in the mud and cannot have good roads unless its politicians protect him.

Col. Robert McCormick, owner and publisher of the *Chicago Tribune,* was a larger-than-life figure with plenty of his own flaws, quirks, and eccentricities. Both McCormick and Small were fiercely partisan and opinionated publishers, unafraid to use their power. McCormick, a staunch Republican, said the Cook County Republican Committee under Thompson and Small was "a criminal organization conducted to the protection of crime for profit." The newspaper also crusaded against gangsters, corrupt politicians, and Franklin Roosevelt. (At left, KPL; below, *Chicago Tribune.*)

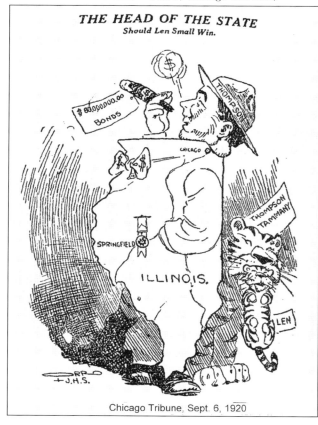

THE HEAD OF THE STATE
Should Len Small Win.

Chicago Tribune, Sept. 6, 1920

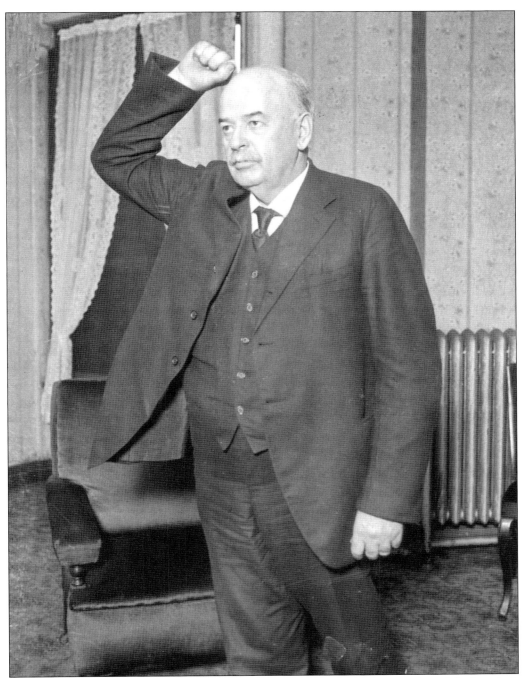

A defiant Gov. Len Small poses for the camera. When Len Small was indicted for his theft as state treasurer, the governor had his lawyers argue in court that he was immune from prosecution based on an old English doctrine that "the king can do no wrong." His defiance was answered by a judge who said there was no king in Illinois and that Small would have to stand trial. (CHM-DN-0072509.)

This is the Tribune Tower on Michigan Avenue, and on the left is the Wrigley Building. Len Small hated the *Chicago Tribune* with a white-hot passion. Small rarely made a speech where he didn't excoriate the *Tribune*; one hour-long speech in Gilman in 1923 included 57 denunciations of the *Tribune*. The *Chicago Tribune* was hard on Small on the editorial pages but fair in its news coverage. It was the contention of Governor Small that the *Chicago Tribune* "championed a cause against the governor," which was the root of his troubles. (JR.)

Five

KANKAKEE POLITICS
CADILLACS BY PRESCRIPTION

Between Chicago and Springfield is the city of Kankakee. To understand the corruption of Len Small and George Ryan, one must understand the politics of Kankakee, where they were bred. The Illinois Central Railroad was building a line through that prairie area in 1853, and it needed a spot for a station. Kankakee County was formed only after railroad workers voted fraudulently and frequently. Another vote was taken to set a county seat, and again the Illinois Central rigged an election to choose a place on their line—a spot that was little more than a mud hole, commonly known as Kankakee Depot, rather than the established Bourbonnais or Momence. The first county board of supervisors meeting was held in Momence, because there were no buildings in the railroad settlement called Kankakee Depot.

The village of North Kankakee got the David Bradley implement factory to relocate from Chicago in 1895 only after a deal that included changing the name of the town to Bradley. Just west of Kankakee, the village of Verkler had a railroad station located there in 1882 only after being shaken down by Thomas Bonfield, the railroad attorney, who demanded the cash payoffs. Bonfield then renamed the village for himself.

In 1961, Kankakee County sheriff Carl McNutt was indicted on 13 charges, including conspiracy with six others to operate houses of prostitution, submitting false bills, and letting prisoners escape. McNutt pleaded guilty to official misconduct and was removed from office and fined. He then was given a state job.

In 2010, Grant Park police chief Scott Fitts was sentenced to five years for running a prostitution sting from his department. He hired a prostitute to lure men and then busted them and shook them down for $400,000 in "fines" before the FBI caught him.

What must be understood is that corruption is not confined to Chicago or to the statehouse in Springfield. It is a part of government in Illinois, even in places like Kankakee.

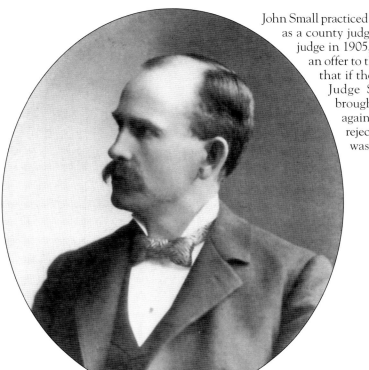

John Small practiced law in Kankakee and served as a county judge. When he ran for circuit judge in 1905, Len Small allegedly made an offer to the Illinois Central Railroad that if they helped John get elected, Judge Small would "fix" cases brought by widows and orphans against the railroad. The railroad rejected the offer and John Small was defeated. (HAHSM.)

William Hunter, an attorney for the Illinois Central, exposed Small's proposal. He called the Smalls "low-minded, wicked men seeking to trade and barter justice for political support." Pictured is the Kankakee Inter-State Fair in 1900, which was operated successfully by Len Small for 40 years. (JR.)

Pictured here in these *c.* 1900 images are John Small (in the buggy) on his farm and the Illinois Central depot in Kankakee. (Both JR.)

Ill. Central Depot,
Kankakee, Ill.

7058.

Edward Jeffers (above, left) and his son-in-law Victor McBroom (above, right) owned an automobile dealership in Kankakee. Jeffers, the McBrooms, the Smalls, and the Ryans ran the local political machine for a century. For decades, it was assumed people in Kankakee knew that if they wanted a job at the state hospital, they had to buy a Cadillac or a Nash from the Jeffers-McBroom dealership. And to keep their job, they had to trade it in every few years. In the McBroom brothers' cafe in Kankakee, political deals were made for decades. (Above, HAHSM; below, JR.)

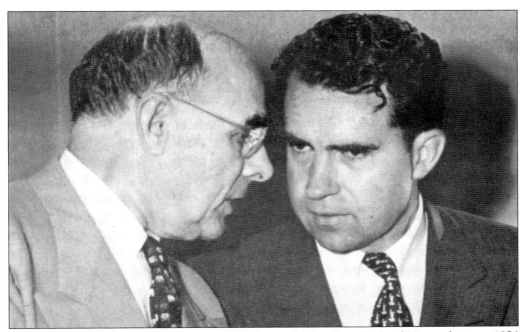

Kankakee political boss Victor McBroom confers with Vice Pres. Richard Nixon during a 1956 campaign stop in Kankakee. Jeffers, the McBrooms, and Tom Ryan held the county chairmanship for nearly 100 years. (HAHSM.)

Victor McBroom was in the state legislature for nearly 20 years. His son Edward followed him in the legislature and as county chairman, for 20 years, continuing the family business. According to locals, employees at Kankakee State Hospital bought cars at his dealership or they lost their jobs. Those who did not make campaign contributions, or who worked for opposing candidates, lost their jobs. George Ryan became Edward McBroom's (seen here) protégé in 1962, and he continued the arrangement, with an added twist—those seeking favors had to have their prescriptions filled at Ryan's pharmacy. (KPL.)

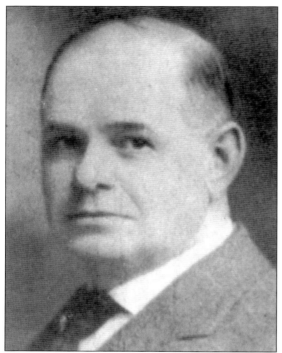

Ben Alpiner was mayor of Kankakee and later a state representative. When he ran against Small's handpicked candidate for mayor in 1911, the *Kankakee Daily Republican* called the Jewish merchant a "shylock who got his pound of flesh from the misery of others." The newspaper frequently used racial slurs against African Americans, Jews, Italians, Poles, Chinese, Mexicans and others, all the way into the 1940s. (KPL.)

To counter criticism from the *Tribune* and the local newspapers, Len Small bought his own newspaper in 1903. Kankakee businessman A.J. Huot said of the *Kankakee Daily Republican* in 1930, "In my estimation, it ranks zero among the other newspapers, but you can't expect much where there are no brains. When it is possible to publish more dirt in one paper, the Small outfit will have the honor if doing it." (KCC.)

George Ryan rose from local politician to state representative to secretary of state and then governor. His brother Tom was mayor of Kankakee for 20 years, a period in which the factory town lost thousands of jobs and unemployment hit 22 percent. While secretary of state, George Ryan's office sold driver's licenses to unqualified drivers. One unqualified truck driver caused an accident in 1994 that killed six children. It was this accident that began a probe into Ryan's corruption that led to his downfall. Ryan was forced to withdraw as a candidate for reelection as governor in 2002. He was indicted on 22 counts of racketeering conspiracy, mail fraud, tax fraud, and more. Ryan was convicted on all counts in 2006 and was sentenced to six and a half years in prison. (KPL.)

George Ryan unveils a truck safety program in 1991 as his office sold driver's licenses for bribes. (JR.)

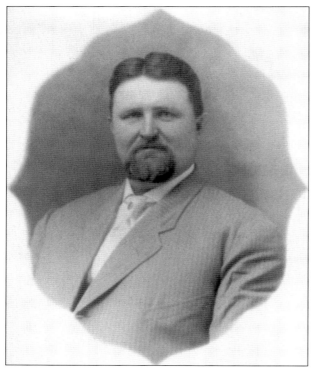

Gangsters and bootleggers shot up Kankakee in the 1920s. Fred Strahl (left) was gunned down behind his speakeasy in 1929. In April 1925, gangster Sam Vaccero was found in his car under 30 feet of water with a bullet in his head. Two days later, retaliation came in a machine-gun battle in the streets of Kankakee, where bootlegger Frank Luppino and gunman Alessio Tortorici were killed. Mafia hoodlum Albert Sirota was "taken for a ride" and shot dead outside the city limits in 1932. Below is the Radeke Brewery in Kankakee, which continued making bootleg beer for several years before being closed by federal agents. (At left, Betty Schatz; below, JR.)

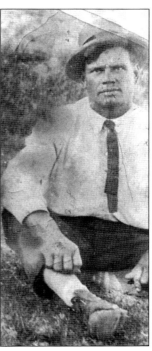

Michael Giusto found a way to hide his bootlegging at his Kankakee shoe shop—he poured homemade moonshine into quart milk bottles and then sold it in shoeboxes. Giusto was arrested in 1923 when a customer squealed after being arrested for being drunk. John Giusto, at right, was one of dozens of Kankakeeans arrested by federal Prohibition agents in raids during the 1920s. The picture below shows federal agents and local police gathering in front of the Kankakee Police Department on February 21, 1925. Some 65 federal agents, led by Charles Vursell, raided 33 places and arrested 33 people that day. Among those arrested were Bruno Matthews, a close political ally of Len Small. (Both JR.)

This was John Giusto's tavern and his Club Roma and Garden City Club on Fifth Avenue in Kankakee, just north of the railroad tracks, in the 1920s. (JR.)

Stephen Small, the great-grandson of the governor, was kidnapped and murdered in 1987. He was renovating this Frank Lloyd Wright house in Kankakee when local hoodlum Danny Edwards took him at gunpoint. Edwards buried Small in a box with an insufficient air tube while waiting for a ransom. Edwards was convicted and sentenced to death, but his life was spared in 2003 when Gov. George Ryan commuted the sentences of everyone on death row. Stephen Small had been a close neighbor of Ryan, shoveling snow from his sidewalk and babysitting his children. (JR.)

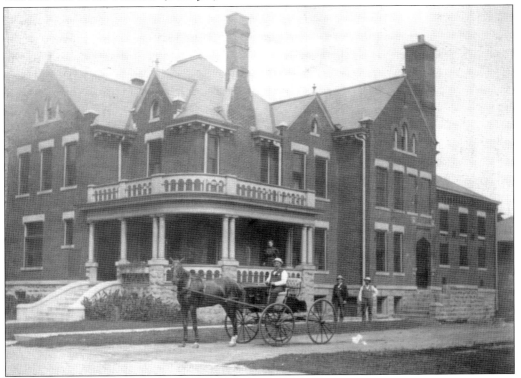

Nell Clark is one of the most famous citizens in Kankakee's history. She was a prostitute and madam who ran a brothel for nearly 50 years. Kankakee was notorious for its houses of ill repute, and Nell's place operated openly. There were occasional busts, but Nell paid her fine and was out of the Kankakee Jail (pictured below) that night. Sometimes the police tipped her about an upcoming raid. Nell died in 1942. She is pictured to the right with her daughter Gertie, who also was in the business. (Both JR.)

Beside Len Small and George Ryan, there was a third man from Kankakee who became governor—Samuel Shapiro, in 1968 after Otto Kerner resigned to become a judge. As a state representative, Shapiro sponsored progressive mental health legislation. His work was real leadership and not just for show. That is why the state hospital at Kankakee was renamed for Shapiro in 1977. Shapiro and Horner, the only two Jewish governors of Illinois, are considered among the most honest and most respected governors. Here Gov. Shapiro (dark suit, shaking hands) campaigns in downtown Kankakee in 1968. (HAHSM.)

Six

A PROUD TRADITION
SLAVES AND SHOEBOXES

This chapter looks at other politicians from the state (not including Chicago). Since 1972, more than 1,000 public officials and related businessmen have been convicted in Illinois (including 19 Cook County judges and 30 Chicago aldermen) according to University of Illinois-Chicago professor Dick Simpson, and to create an account of their purported crimes would take a set of encyclopedias.

Of the state's first seven governors, four (Shadrach Bond, Ninian Edwards, Edward Coles, and William Ewing) were slave owners and three (John Reynolds, Joseph Duncan, and Thomas Carlin) were pro-slavery. Two governors (William Bissell and Len Small) were constitutionally ineligible to be governor but were elected and served. Once both the governor and lieutenant governor (Bissell and Hoffman) were legally ineligible. One governor (Richard Yates Sr.) was too drunk to give his inaugural address. Three governors have been convicted of felonies and sent to prison. Two former governors acted as attorneys at corruption trials for two other governors (Joseph Fifer for Len Small and James Thompson for George Ryan). Once both the incumbent governor and lieutenant governor (Small and Sterling) stood indicted for embezzlement. One governor (Small) was acquitted after gangsters bribed the jury.

Only in Illinois could convicted felon George Ryan be rewarded for his actions by being nominated for a Nobel Peace Prize by his pals, while impeached former governor Rod Blagojevich gave a lecture on ethics in politics at Northwestern University.

Gov. Ninian Edwards (pictured) owned slaves and ordered the slaughter of friendly Native American villages. Gov. John Reynolds believed in the moral and legal right of slavery and once offered a $50 reward for an escaped slave. Gov. Thomas Ford mishandled the volatile Mormon situation, causing the murders of Joseph and Hyrum Smith. Gov. Richard Yates was so drunk on inauguration day that he kept Abraham Lincoln waiting 30 minutes before staggering down the aisle and collapsing in a chair. (KPL.)

When Joel Matteson (seen here) became governor in 1853, he found a trunk and a shoebox filled with $338,000 in canal scrip that had been cashed; the scrip had not been cancelled or recorded. Matteson was able to cash it in again as well as cashing in unissued scrip. By repaying most of the money he claimed he had not stolen, Matteson avoided prosecution. (JR.)

William Bissell (pictured) made a speech that brought a challenge to duel from Sen. Jefferson Davis. Bissell accepted, but Davis backed down. Illinois banned state officials from dueling or accepting a challenge to duel. This made Bissell ineligible to serve, and he thereby committed perjury when he took the oath. Bissell died in office of what some say was syphilis. An audit in 1894 showed the state treasury held $50,000 in promissory notes from Gov. John Peter Altgeld, who borrowed money to finance a real estate deal. Political friends repaid the money and covered up the scandal. (KPL.)

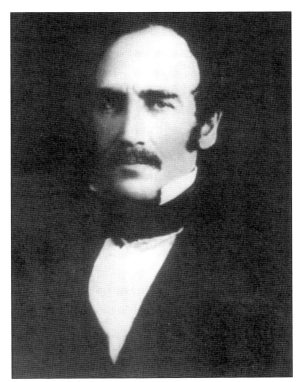

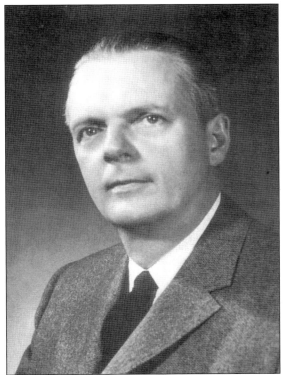

Gov. Dwight Green, who built his reputation as a prosecutor that sent Al Capone to prison, was accused of overlooking gambling rackets and accepting campaign contributions from gangsters. Gov. William Stratton (pictured) was indicted in 1965 on charges of income tax evasion for alleged improper use of campaign funds but was eventually acquitted. Gov. Richard Ogilvie, as sheriff of Cook County, had a reputation as a man who took on the Mob. But his chief investigator was Richard Cain, a corrupt Chicago police officer and a ranking member of the Chicago Outfit. Cain was gunned down by the Mob in 1973. (KPL.)

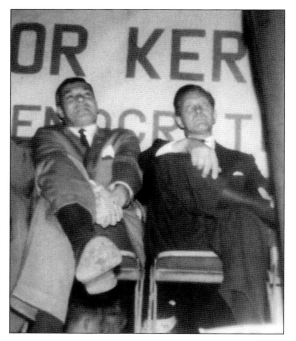

Gov. Otto Kerner Jr. (on the right, campaigning for reelection in Joliet in 1964) resigned in 1968 to become a federal judge. In 1969, Marge Everett, manager of Arlington Park Racetrack, admitted bribing Kerner to get choice racing dates and expressway exits for the track. Incredibly the scandal was revealed because Everett deducted the bribe on her federal income tax returns, believing that bribery was a normal business expense in Illinois. Kerner was convicted on 17 counts of bribery, conspiracy, and perjury. He was sentenced to three years in prison. Gov. Daniel Walker was convicted of improprieties with a savings and loan in 1987 after leaving office. He served 18 months in prison. (JR.)

Gov. Rod Blagojevich was arrested by FBI agents in 2008 and impeached in 2009. Blagojevich was indicted on charges of racketeering, attempted extortion, bribery, and more. Among the accusations are that he tried to sell Pres. Barack Obama's former senate seat and withheld $8 million due to Children's Memorial Hospital while trying to extort $50,000 from its chief. Blagojevich (pictured here) was convicted in August 2010 of lying to the FBI. A mistrial on the other counts will result in a second trial. (KPL.)

When the state indicted former treasurers Len Small and Fred Sterling in 1921, it also investigated the previous 10 treasurers for having kept interest on state deposits. This included Andrew Russel (pictured), who put $3 million of state money in a bank he owned and gave no interest to the state. Russel, later convicted of bank fraud, died in a federal prison. Henry Wulff, state treasurer from 1895 to 1897, stole thousand of dollars, which the courts forced him to repay. That decision said all state treasurers and their bondsmen, going back to 1872, had to pay a total of $321,000. (JR.)

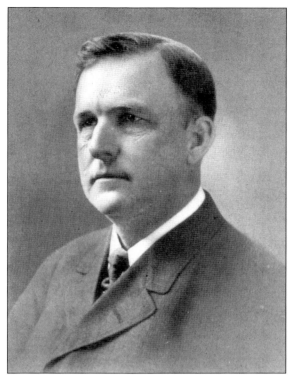

Jerry Cosentino (seen here), state treasurer from 1979 to 1983 and from 1987 to 1991, pleaded guilty in 1992 to bank fraud. Alexi Giannoulias, elected state treasurer in 2006, saw his family-owned Broadway Bank in Chicago seized by federal bank regulators in 2010. Giannoulias presided over a $150 million loss in the state's Bright Start college savings program because of bad investments. (KPL.)

Paul Powell was elected secretary of state in 1964 after 30 years in the legislature. Powell never earned more than $30,000 a year, but he left an estate of $4.6 million, including $750,000 in shoeboxes found in his home, after his death in 1970. A good part of that money consisted of checks not cashed made out to the secretary of state for license plates. For all his decades of legislative work, Powell will forever be a legend in Illinois for his shoeboxes. (JR.)

State auditor Orville Hodge embezzled $6 million from the state by altering and forging checks. Hodge bought two private jets, 30 automobiles, and property in Florida and Illinois. Hodge was indicted in 1956, pleaded guilty to bank fraud, embezzlement, and forgery, and was sentenced to 15 years in prison. Attorney general William J. Scott was convicted in 1980 on tax charges for misusing campaign funds and was sentenced to one year in prison. (KPL.)

Roy Solfisburg Jr. (right) and Ray Klingbiel (below) both served as chief justice of the Illinois Supreme Court in the 1960s. Both men resigned in 1969 after revelations they took stock from a Chicago bank at the same time litigation involving the bank was before the court. Cook County judge David Shields was convicted in 1992 of taking $5,000 to fix a case and went to prison. Cook County judge Thomas Maloney was convicted of taking bribes from street gangs to convict members of other gangs on murder or manslaughter charges and went to prison. Cook County judge Frank Wilson took a $10,000 bribe to acquit Mob hit man Harry Aleman of the murder of a union boss. As the investigation into Wilson got closer, the retired judge committed suicide. (Both KPL.)

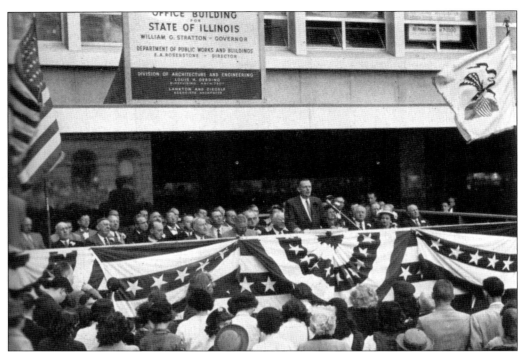

Illinois governors sure do like honoring themselves. Counties are named for Shadrach Bond, Edward Coles, Ninian Edwards, and Thomas Ford. Towns are named for Edwards, Thomas Carlin, Joel Matteson, John Oglesby, Shelby Cullom, and Richard Yates. There are statues and museums for John Palmer, Yates, Oglesby, Altgeld, Coles, Bissell, Tanner, Small, and more. Altgeld has castle-like buildings named for him at the state universities. A college athletic center and water park is named for George Ryan. State parks are named for William Stratton and Frank Lowden. The state office building near the capitol was renamed for Stratton (who dedicated it in 1954, above). The State of Illinois Building in Chicago was renamed for James Thompson. The Centennial Building in Springfield was renamed for Secretary of State Michael Howlett. A train station in Chicago is named for Richard Ogilvie. If that were not enough, in 1969 the state created Governor's State University. (KPL.)

Some people would say not much has changed since the author drew this cartoon, which was published on December 15, 1978. (*Daily Times.*)

This is a view of the capitol in 1927. Springfield is in Sangamon County, named for a Native American word meaning "the land of plenty to eat." That certainly has been true for politicians. Chicago newspaper columnist Mike Royko suggested Chicago's motto should be *Ubi Est Mea* ("Where's Mine?"). Political writers Rich Miller and John Kass do not shy from linking the political machine with the Chicago Outfit. Kass writes that the Chicago machine is the "iron triangle, consisting of the Democrat Machine, Republican Insiders and the Chicago Outfit." Chicago commentator Tom Roeser calls the Democrat Machine "The Squid, with arms, tentacles and an ability to eject an inky camouflage. If its head is lopped off, it generates another one and survives." Charles Merriam, a reformer before 1920, called it the "Big Fix," a combination of corrupt politicians, businessmen, and gangsters preying on an apathetic and distracted public. Merriam's famous quote was that "Chicago is the only completely corrupt city in America." (KPL.)

POSTSCRIPT

The reader may be wondering how any of these infamous Illinois politicians ever got elected. Governor Small's luck is explained in a January 22, 1924, *Chicago Tribune* editorial:

> Maybe his bad record is a help to him. Sometimes we think it is a vote-getter for him. It is so bad it is unbelievable. When the truth is told, people say it cannot be so, and that there must be a vicious reason behind the telling of it.
>
> Some of the women are just discovering that he pardoned out of the penitentiary a man and woman sent there for pandering (white slavery). Small will say that he was protecting them from injustice and some people will believe that, because they cannot believe he would let a pair of convicted panders out. His explanation of having the packers' notes, of the nonexistent Grant Park Bank, and the disappearance of the interest the packers paid is ridiculous. People may believe him, reasoning to themselves that the truth cannot be true, it is so bad.

Selected Reading

Angle, Paul M. *Bloody Williamson*. New York: Alfred A. Knopf, 1952.

Bergreen, Laurence. *Capone, The Man and the Era*. New York: Touchstone, 1994.

Binder, John J. *The Chicago Outfit*. Chicago: Arcadia Publishing, 2003.

Howard, Robert P. *Mostly Good And Competent Men*. Springfield, IL: University of Illinois, Institute For Public Affairs, 1988.

Keefe, Rose. *The Man Who Got Away: The Bugs Moran Story*. Nashville: Cumberland House, 2005.

———. *Guns And Roses: The Untold Story of Dean O'Banion, Chicago's Big Shot Before Al Capone*. Nashville: Cumberland House, 2003.

Kobler, John. *Capone: The Life and World of Al Capone*. New York: DaCapo Press, 1971.

Lyle, John L. *The Dry And Lawless Years*. New York: Prentice-Hall, 1960.

Nash, Jay Robert. *World Encyclopedia of Organized Crime*. New York: DaCapo Press, 1989.

Ridings, Jim. *Len Small: Governors and Gangsters*. Herscher, IL: Side Show Books, 2009.

———. *Wild Kankakee*. Herscher, IL: Side Show Books, 2011.

Schoenberg, Robert J. *Mr. Capone: The Real and Complete Story of Al Capone*. New York: Quill, 1992.

Wendt, Lloyd, and Herman Kogan. *Big Bill of Chicago*. New York, Bobbs-Merrill, 1953.

Wooddy, Carroll H. *The Case of Frank L. Smith: A Study In Representative Government*. Chicago: University of Chicago Press, 1931.

www.arcadiapublishing.com

Discover books about the town where you grew up, the cities where your friends and families live, the town where your parents met, or even that retirement spot you've been dreaming about. Our Web site provides history lovers with exclusive deals, advanced notification about new titles, e-mail alerts of author events, and much more.

MADE IN THE USA

Arcadia Publishing, the leading local history publisher in the United States, is committed to making history accessible and meaningful through publishing books that celebrate and preserve the heritage of America's people and places. Consistent with our mission to preserve history on a local level, this book was printed in South Carolina on American-made paper and manufactured entirely in the United States.

This book carries the accredited Forest Stewardship Council (FSC) label and is printed on 100 percent FSC-certified paper. Products carrying the FSC label are independently certified to assure consumers that they come from forests that are managed to meet the social, economic, and ecological needs of present and future generations.

FSC
Mixed Sources
Product group from well-managed forests and other controlled sources

Cert no. SW-COC-001530
www.fsc.org
© 1996 Forest Stewardship Council

Find Your Place in History.